THE ART OF DRAWING

FLOWERS, FRUIT & VEGETABLES

SIMPLE APPROACHES TO DRAWING NATURAL FORMS

Giovanni Civardi

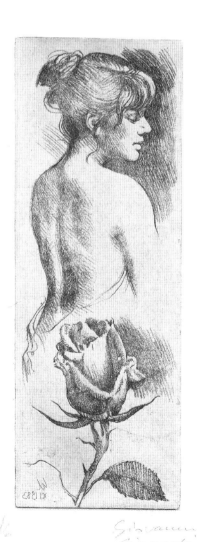

SEARCH PRESS

Giovanni Civardi, November 2007

Giovanni Guglielmo Civardi was born in Milan in 1947. Following a period working as an illustrator, portraitist and sculptor, he spent many years studying human anatomy for artists. He also teaches courses on how to draw the human figure.

'Dicit: sed mulier cupido quod dicit amanti,
in vento et rapida scribere oportet aqua.'
(...the words of a woman to her ardent lover are fit to be
written on the wind and fast-flowing water...)
 Caio Valerio Catullo

Ha bisogno di qualche ristoro
Il mio buio cuore disperso...
(...my darkened, straying heart
needs some refreshing repose...)
 Giuseppe Ungaretti

First published in Great Britain 2011 by Search Press Limited, Wellwood, North Farm Road, Tunbridge Wells, Kent TN2 3DR

Originally published in Italy by Il Castello Collane Tecniche, Milano

Copyright © Il Castello S.r.l., via Milano 73/75, 20010 Cornaredo (MI), 2010 Fiori, Frutta e Ortaggi

Translation by Cicero Translations

Typeset by GreenGate Publishing Services, Tonbridge, Kent

ISBN: 978-1-84448-682-3

Printed in Malaysia

CONTENTS

INTRODUCTION

First learn to sketch, then to finish your work.
Michelangelo (to Jean Boulogne)

So-called 'still life' has long been an important part of artistic expression, and flowers, along with fruit, vegetables and other food items, as well as articles of everyday use, are its preferred subject matter. Indeed, images of flowers, fruit and plants appear on early historical artefacts from almost every civilization including those of China and Japan. You will see them in the wall frescoes and mosaics of Ancient Rome and the botanical manuscripts of the Medieval and Renaissance periods, where they carried symbolic meaning. The position of such subject matter as a separate genre did not come about until the 17th century in northern Europe, when what were at first details in more comprehensive paintings such as portraits and depictions of historic or religious scenes took on the status of subjects in their own right. Still-life painting became very popular and much sought after, partly because of the skill with which artists were able to render particularly complex forms. In the centuries that followed, this genre of 'silent nature', as some prefer to call it, has expanded and developed – think of the varied styles of Chardin, Monet, Van Gogh, Braque, Picasso, Matisse, Morandi and many others, for example.

Flowers, with their great variety of colour and form, are one of the most fascinating subjects for painting, drawing and, above all, for engraving, which requires such a meticulous technique that the most intricate botanical details can be rendered. But other, more practical reasons recommend careful and continuous practice in depicting flowers as a subject of choice.

Like fruit, they can easily be found anywhere or can be bought at a reasonable price; they can be kept for a period of time (for long enough at least to be drawn precisely); they can be studied individually or grouped into complex compositions and they can be cut into sections for examination of their internal structure. In other words, flowers provide the artist with training in the skill of careful observation and practice in capturing different aspects of surface and structure. In addition, these subjects offer the artist limitless scope for creative and stylistic expression, for composition or for depiction using light and shade. They can contribute to laying down the technical basis required for tackling more complex and challenging subjects such as the human figure or face.

It is worth mentioning at this point that there are two fundamentally different approaches to drawing flowers and other plant life: two approaches which may, however, find ways of enriching each other. Scientific-style 'botanical' studies (as exemplified by the medieval herbarium) have the main objective of providing a clear and simple description of the most striking physical characteristics typical of a particular flower, leaf, fruit or plant. In contrast to this, in the case of purely 'artistic' drawings, the artist's overriding intention is to find inspiration in botanical subjects in order, through exploring its form, to express emotions or ideas, freely exploiting the subject's graphical, pictorial and aesthetic potential. I would nonetheless suggest that the route to artistic knowledge begins with careful observation, which, if it avoids deteriorating into sterile pedantry or imposing a suffocating straitjacket of rules, will form the foundation of an intelligent visual appreciation which can only empower an artist's ability to interpret freely and convincingly.

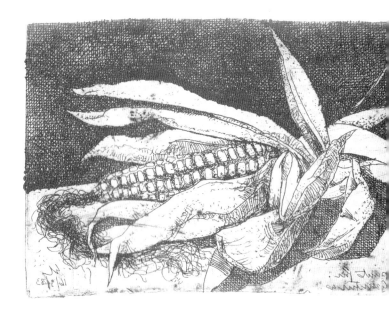

Corn on the cob (study for Indian Corn), etching (1983), 59 × 116mm (2³⁄₈ × 4¹⁄₂in).

GETTING STARTED

Although colour is one of the most striking characteristics of any botanical subject, and of flowers in particular, I have limited myself in this book to the best of all graphic mediums: pencil on paper. I have done this in order to help concentrate our attention on the observation of structure and form, rather than on attaining aesthetic effects through the use of colour. Nonetheless, I hope you will be able to supplement these studies with some written notes on colour, or, if preferred, with work using traditional media such as coloured pencils, pastels, watercolours, etc., which combine well with traditional pictorial techniques.

In short, when drawing these subjects, especially when working outdoors directly from the subject, the simplest and most common tools can be used: pencil, charcoal, pen and ink, felt-tipped pens, ink wash, etc. Each of these mediums will produce different effects, not only due to the specific characteristics of each tool and technique, but also depending on the support: smooth or textured paper, card, white or tinted paper, etc.

Pencil and graphite on paper Thanks to its characteristic properties – ease of use, expressiveness and precision – the pencil is the most widely used tool for any type of drawing. It can be used to create highly finished works or simple thumbnail studies and sketches for reference. Soft graphite pencils are especially suitable for the former while the finer leads of mechanical pencils are suitable for the latter. Graphite leads may be inserted in button-operated mechanical pencils or encased, as with traditional pencils, in easy-to-hold wooden sheathes. Leads are graded according to hardness, from the very hard 9H, which leaves a fine, pale line, to the very soft 6B, which will create a large, dark mark on the paper with little effort.

Pen and ink There are many different types of pens and nibs, each creating distinct, characterful effects, including bamboo pens, fountain pens, calligraphy pens, technical pens (such as the Rapidograph), felt-tipped pens and ballpoint pens. Tonal variations are usually achieved by hatching pen strokes, worked closely or loosely and at various angles. For this reason it is advisable to work on a smooth paper or card with a sturdy surface that will not tear, resulting in irregular take-up of the ink. (See also Lavis, below.)

Charcoal With this very versatile medium, intensities of tone can be controlled with ease, while it is also possible to attain a high degree of detail. Charcoal should, however, be applied fluently, aiming at an overall rendering of tonal masses and structural volume – an approach that brings out the best qualities of this agile and evocative medium. The choice is between compressed charcoal, which has a compact consistency that offers bold, vigorous lines, and natural charcoal in the form of soft, brittle sticks of carbonised willow. In either case, care must be taken not to leave smudge marks on the paper. Charcoal lines can be built up or subtly shaded off (using your finger, for example) and shading can be made lighter by dabbing with a soft eraser (a putty eraser). The finished drawing should be protected with a coat of spray fixative.

Lavis (monochrome or 'half-tone' wash) When suitably thinned down with water, watercolours, water-soluble inks, tempera or Indian ink lend themselves very well to flower or botanical studies in general. These mediums are, however, more closely related to painting than to schematic drawing as they are applied by brush and require concise, expressive shading. For rapid studies from life, water-soluble graphite sticks or pencils (black or coloured) can be used. Marks made with these pencils can easily be dissolved by running a wet or moist brush along them. For this kind of work, watercolour paper, heavy card or pasteboard is preferred to avoid puckering of the paint-bearing surface.

Mixed media This means combining different drawing media, often with the intention of creating an unusual or elaborate effect. These are still 'graphic' media but combining them calls for familiarity with the tools used as well as with the principles of painting, otherwise the results will appear confused and have little aesthetic appeal. Mixed media can be very effective when applied on coloured, textured supports, which should ideally be dark in tone.

WHERE TO FIND YOUR SUBJECT

At the right time of year, fruit and vegetables can be found in allotments, gardens and farmers' fields. If you do not live in the countryside, fruit and vegetables are easily obtained in markets or shops. In either case, it is advisable to select examples displaying all of the typifying traits of the variety (shape, colour, ripeness, etc.) but which also display interesting individual features (in the stalk or the leaves, for example). Flowers are even easier to obtain: interesting subjects can be found and studied directly in their wild habitats where they grow spontaneously, but also (which may be more convenient for city dwellers) in private gardens and public parks, in botanical gardens, greenhouses, or in pots or as cut flowers as they are sold in many commercial outlets.

Cultivated flowers can now be found at just about any time of year, irrespective of whether they are in season. Such specimens are often highly pleasing aesthetically. Of course, cut flowers will wither more quickly than those with roots and therefore need to be drawn or painted rapidly before irreversible deterioration sets in as petals fall and stalks begin to wilt. There are simple tricks that help slow down this process of decay: for example, keep cut flowers in a cool, well-lit and humid environment; change the water in their container frequently and add nutrients to it; cut off a short section of the stem each day, etc. In the absence of natural fruit or flowers to serve as your subject, artificial substitutes could be used, but I think this is a practice best avoided because, even with perfect reproductions, that element of empathy with the subject, which is part of the process of observation, will be denied, not to mention the difference there will be in the physical structure. And flowers, when they have dried or even

withered and faded, may still provide a source of interest, particularly with regard to their structure and texture.

HOW TO STUDY BOTANICAL SUBJECTS

Drawing from life is, without doubt, the best and most rewarding method of portraying flowers or fruits because it requires direct and careful observation and provides a concrete object for your artistic response. Even a quick sketch – a form of visual note taking that functions as a simple reminder of an object – may turn into the first draft of a more carefully elaborated drawing. With this in mind, we should always carry a pocket sketchbook and pencil with us, as interesting subjects tend to present themselves when least expected and in unrepeatable circumstances.

Drawings can also be very complex and highly finished, depending on the artist's intentions and purposes. As we shall see (page 14), scientific botanical drawings require precision and clarity in the way they represent the overall form of the subject and its structural features (stamens, petals, stems, leaves, phases of development, etc.) so that the species or variety can be identified. These visual records can be accompanied by written captions conveying further information and references to colour that supplement and clarify the description. The 'artistic' drawing, which is closer to our focus of interest, has very different – exclusively aesthetic – goals and with them different approaches to interpreting the subject. In this case, although still indebted to the actual form and function of the subject, the artist's emotional response will direct the drawing towards presenting the subject in a way that satisfies the artist's intention and stylistic needs. Having said that, it is clear that the borderline between the botanical approach to drawing and the artistic one is not static: each approach contains, to varying extents, a part of the other both in terms of the ways in which forms are perceived and the ways in which they are rendered. As well as being precise, a scientific study can be a beautiful thing that arouses the emotions, while it is possible for an 'artistic' drawing to be dry and devoid of meaning even though it is imaginative.

Should you lack the time needed to carry out studies directly from life or if you wish to collect documentary material that you can study later on at your ease, photography is an option. Digital images have the fascinating advantage that they can be greatly enlarged on the computer screen, allowing you to perceive (while being careful not to fall prey to optical illusions) minute details or short-lived effects that normally elude the eye even of an attentive observer. When taking photographs of flowers or of reasonably small edible vegetables, there are some good technical tips to ensure that you produce images which provide a suitable resource for later study:

- Do not simply photograph the flower or the fruit alone, but, if possible, include the whole plant in its natural growing environment.
- Keep your back to the light or have it angled from the side in order to throw the lumps and bumps of structural detail into relief along with the volumes and surface details.
- Take a close-up shot of the whole subject, including its most important details, bearing in mind the inevitable distortions produced by perspective.
- Experiment with taking some shots from unusual angles.
- Draw a diagram of the subject and note down its significant features.

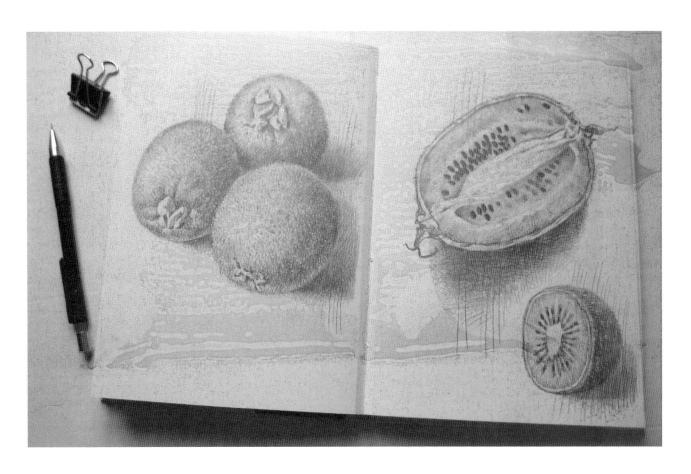

HOW TO OBSERVE

Whether your subjects are flowers, fruit or vegetables, the method of learning to see (which is not as easy as just looking) is always the same: observe, understand and interpret. For the artist, observation means visually investigating the subject and following your curiosity for what is unusual or exceptional; understanding means learning about a subject in a scientific way but always from a sensitive and artistic slant; and interpreting means rising above your emotions to communicate creatively.

PRACTICAL TIPS

Here are some practical tips for drawing botanical subjects (but with the accent on flowers), many of which will be developed later in this book:

- First identify the overall form and the essential structural lines of the subject by looking at it from different viewpoints and then choosing the most suitable angle from which to represent it.

- In order to transfer the subject's three-dimensional volume on to flat paper, first reduce the forms to simple geometric shapes or elementary solids (squares, circles, ellipses, cubes, cylinders and so on). This will make it easier to judge the effects of foreshortening when applying the elementary rules of linear perspective.
- After the initial overall assessment of the whole subject, you can begin to develop the minor forms and details. It is not necessary to draw everything you see: it is a good idea to simplify and leave out insignificant details as part of the 'good housekeeping' of your drawing. However, as an exercise in observation, you can try reproducing every last detail in a flower, for example, exploring the relationship between one example and another.
- In any case, it is important to avoid considering every single detail in isolation, but instead see it as part of the whole structure.
- Evaluate the relationships between the positive shapes (leaves, stems, flowers and so on) and the negative spaces, (the gaps between and within objects).

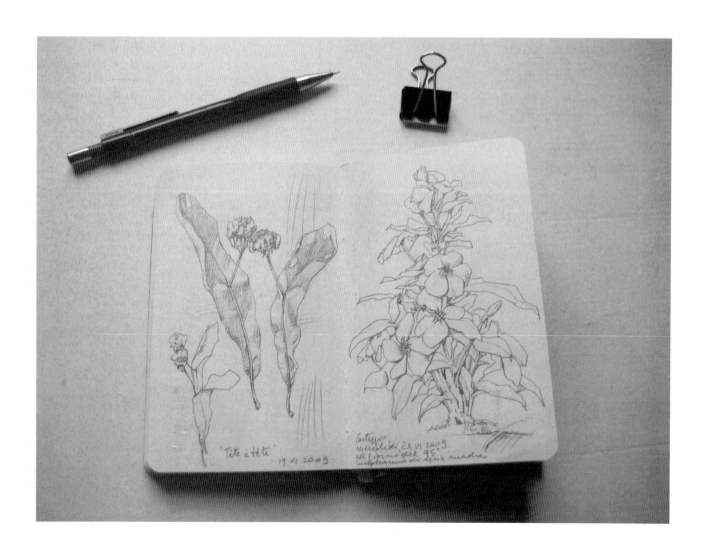

- When organising a composition (whether it involves one or more items), it is advisable to select elements that create contrasts of tone, scale, form and/or surface texture. For example, flowers can be arranged in a vase, keeping an eye on their height, the angle at which they stand or the direction in which their flower heads and leaves are facing (face on, in profile or foreshortened). An overall impression of spontaneous, but non-random, simplicity can be created and the arrangement will be rich in details to explore. It is important that the positions of the main elements of a composition are set at the outset or early on and that they are treated in the same way as neighbouring elements.
- There is more to a flower than just its petals, although it is these that attract our gaze. Plants are complex in structure and the stem and leaves are equally important. Does the stem bear a single large flower or a sequence of blooms? Are the leaves simple or complex? How are they attached and how are they arranged on the stem?

What is the pattern of the leaf veins? Is the corolla (all the petals) mainly circular in shape or is it a polygon, sphere or cylinder? A drawing made as a study should concentrate not just on graphic and aesthetic qualities, but also on portraying the typical and essential characteristics of the flower.

- A lot of attention should be paid to the lighting conditions, especially the intensity and direction of the light. Flowers are characterised by their surface structures and their many subtle graduations of tone, which are essential for conveying an effect of volume.
- The structure and internal forms of botanical subjects may easily be viewed by cutting through them, either along their length or in cross section. Cutting a flower is not so easy because it is soft and prone to collapsing and may be squashed by the pressure of a knife. This can be overcome by putting the flower head and a part of the stalk into a freezer for about twenty minutes and then slicing through it using a fine, serrated blade.

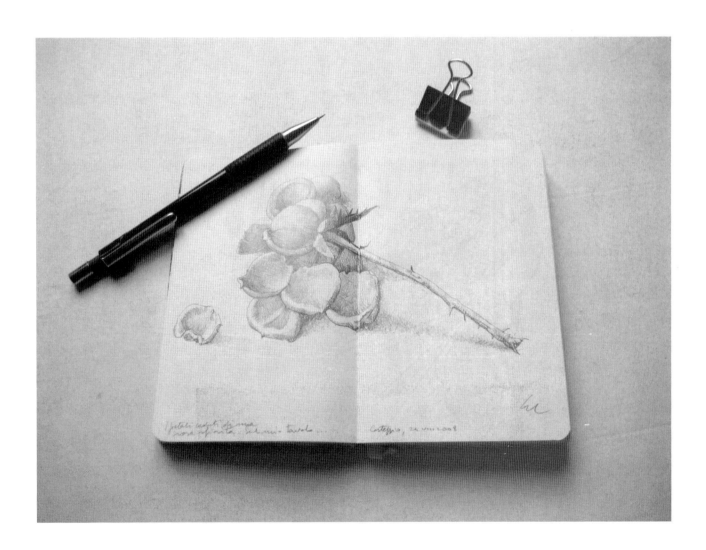

PERSPECTIVE

Linear perspective creates an effect of spatial distance through the progressive reduction in size of the objects portrayed as they move further away. By following these basic principles, the artist will be able to correct – and also understand – 'intuitive' perspective as it is perceived by the eye. In linear perspective, a sense of depth is produced by tracing the apparent heights of objects on to one plane and gradually reducing these heights as they recede from the observer. When drawing small natural forms, such as some flowers or fruit, the perspective effects may not be very apparent – although they still exist – and it is necessary to have a good understanding of how perspective works in order to accentuate or reduce its effects in the interests of creating a realistic drawing. It is particularly important to consider the way that perspective distorts not just linear forms such as leaves and stalks, but also cylindrical shapes (a container holding cut flowers, for example) and circular shapes (such as the large corolla of a flower) as these are items that occur again and again in this type of art.

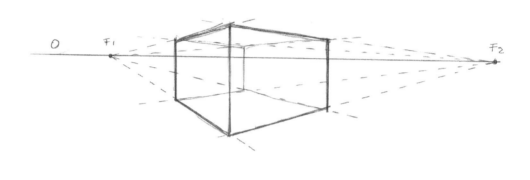

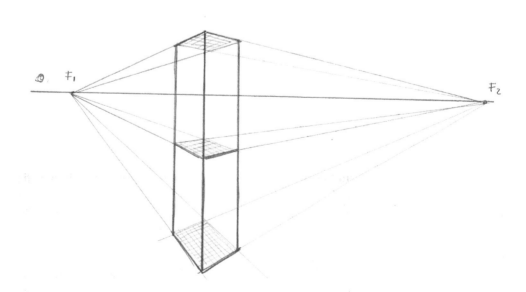

Angular linear perspective (also called oblique perspective) uses two vanishing points (F1 and F2), which are located towards opposite ends of the line representing the horizon (O). Its effects (which, for simplicity's sake, are seen here using simple geometric shapes) are evident in an edge-on view. All the vertical lines stay vertical, but their heights are reduced as they approach the horizon and appear to recede into the depths of the page. The horizontal lines, on the other hand, converge on one of the two vanishing points, projecting the objects in 'foreshortened' view.

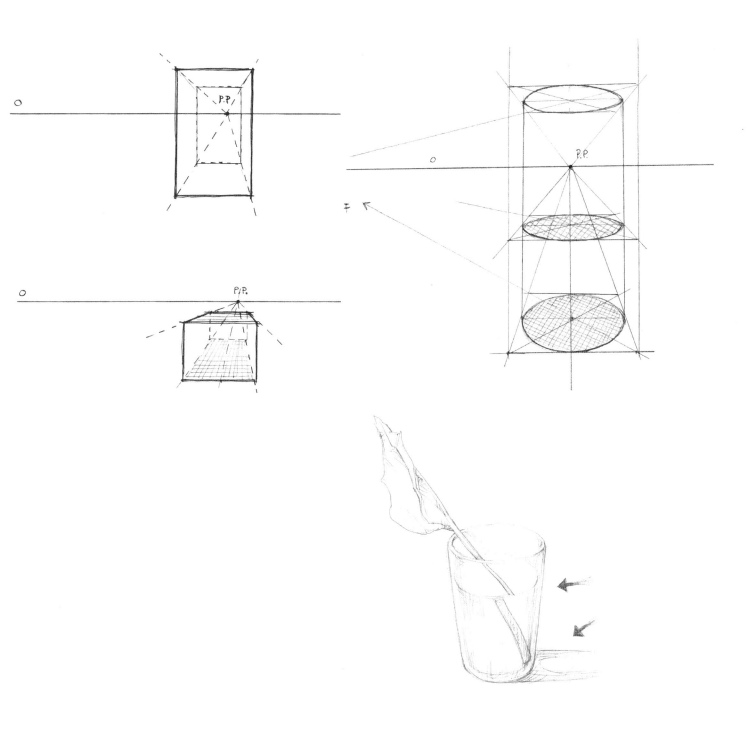

Central linear perspective (one-point perspective) is based on the principle that the non-vertical lines of the object converge on a single point (PP) on the line of the horizon (O). Here the object is seen with its leading face parallel to the plane of the perspective 'frame'.

In either case, the line of the horizon always corresponds to the observer's eye level and is determined by the viewpoint, i.e. the position from which the object is being observed.

The top and bottom faces of a cylinder are circles (as are any intermediate parallel cross sections) and the effect of perspective on these circles will vary in relation to the horizon, turning them into ellipses that are more and more 'squashed' as they approach the line of the horizon, and progressively wider as they move away from it, depending on the viewpoint. It is essential to bear this process clearly in mind when drawing a flower vase, for example, or vegetables such as courgettes, carrots, parsnips and so on.

When drawing cut flowers with their stems visibly standing in the water of a transparent container, do not overlook either the optical effect of refraction or the 'magnifying-glass' effect. These phenomena are described by the laws of physics and can be calculated precisely using optical formulae (which take the differences in density between air and water into account, among other things). Working by eye, pay special attention to the positions and changes in dimension of the various segments or the differences in intensity in the shadow cast by the object.

COMPOSITION

With drawing, as with painting, composition consists of choosing the figurative elements you wish to depict and organising them in relation to each other and in relation to the edges of the paper or other support. The composition will, to a large extent, depend on the artist's intuition and 'visual education'; there are no hard-and-fast rules. It is possible, however, to refine our understanding of composition by studying works of art from the past and present and by looking at some of the experimental

psychological research that has been done into visual perception. Some general human tendencies emerge along with information about how best to fulfil our requirements for harmony based on our perception of the environment and of spatial organisation. For example, some principles (of unity, contrast, balance, convergence and dispersion) have been formulated which can enhance the way a work of art conveys such feelings as calm, stability, tension or conflict.

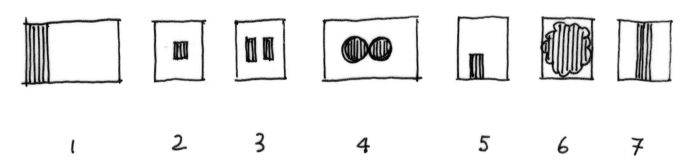

1 2 3 4 5 6 7

In normal situations, when you are not trying to create specific effects, practical experience suggests that there are some compositional layouts that are best avoided because they usually cause an impression of monotony or a sensation of visual awkwardness. For example, avoid positioning objects just along one side of the support (1) or

in the absolute centre (2); avoid arrangements that are perfectly symmetrical (3) or in which the profiles of adjacent objects come into contact (4); avoid positioning the subject on the bottom edge of the support (5) or right down the middle (7), and avoid filling all of the available space (6).

The art of flower arranging is timeless, but when drawing it is perhaps better to avoid over-elaborate or excessively complex set-ups. If your aim is to attain simple and effective results, study the example layouts on the pages of this chapter and bear the following compositional guidelines in mind:

- Position a single object (a flower or a piece of fruit, etc.) so that it is seen from its most suitable and significant angle.
- Arrange groups of similar objects (either flowers or fruit, etc.) in a way that creates a variety of shapes and tones.

- Arrange objects and containers in mixed groups (flowers with fruit or fruit with vegetables, for example).
- When making the arrangement for a still life, think about contrast, depth and the relationships between objects in terms of their shapes, colours and tones and use these to guide the viewer towards a central focus of interest.

BOTANICAL ANATOMY

For the artist, drawing from life is an essential way to sharpen the skills of observation and visual perception. The diligence and attention required for this activity will, in fact, bring about a new way of seeing, whereby you find yourself exploring even the most familiar and ordinary objects. It will also help you gain greater insight into the relationship between overall form and individual detail.

It is by no means necessary to study botany in order to be able to draw fruit, vegetables or flowers, nor do you need an in-depth knowledge of plant anatomy and morphology. However, some information relating to the basic structures, at least of flowers and leaves, can prove very useful in helping to identify and understand the specific characteristics and details that differentiate one variety from another.

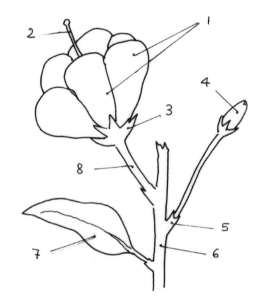

Here are some of the main parts you will see on a flower and its stem: the corolla, which comprises all the petals (1); the stigma (female part) which catches incoming pollen – the pollen-bearing stamens (male) are often lower and not always seen from this angle (2); the sepals, which protect the flower when it is just a bud, with the receptacle sometimes apparent as a bulge (3); the bud (4); the node on the stem from which leaves, flowers and so on grow (5); the stalk (6); the leaf (7) and the peduncle or stem of an individual flower or inflorescence (8).

Flowers contain the plant's reproductive organs and after successful pollination they bear the fruit(s) or seeds. In the case of a fruit, the pericarp surrounds the seeds, pip(s) or stone. The pericarp consists of three layers, which vary according to the fruit type. In the case of nuts, the exterior layer is hard and woody; in the case of fleshy fruits, the two innermost layers are succulent or fleshy – the part we eat.

The leaf is the main site of a plant's photosynthesis, respiration and transpiration (giving off water vapour). Nearly all are fairly flat, but shapes, profiles and sizes vary enormously and are mostly designed by nature for the conditions in which the plant grows – desert, alpine regions, temperate climates and so on.

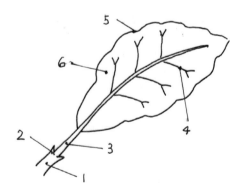

The diagram opposite shows the basic parts of a leaf: the node (1); the stipule, which is only present on some leaves (2); the petiole or leaf stalk (3); the veins, with the midrib down the centre (4); the margin, which is the very edge of the leaf (5) and the blade or lamina, which is the main body of the leaf (6).

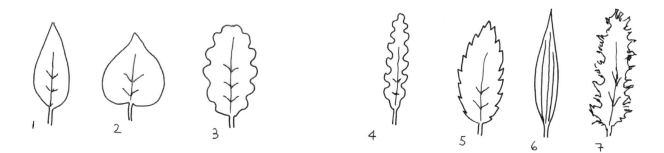

Here are examples of some common leaf shapes: ovate, which is egg shaped (1); cordate, which is heart shaped (2); lobed ovate (3); lobed (4); elliptic, here with a dentate margin (5); linear (6) and elliptic with a spiny margin (7).

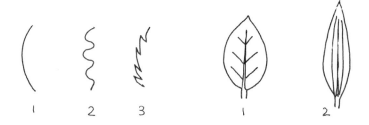

Leaf margins (edges) vary and include: smooth (1), sinuate (2) and dentate (3) forms.
Venation (the pattern of veining) can be equally varied and includes the common pinnate (1) and also parallel (2) forms.

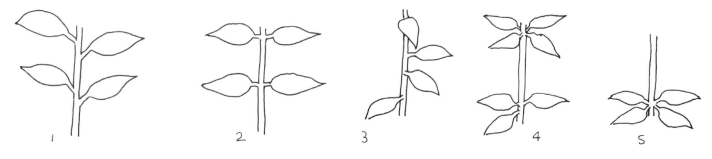

Notice the way that leaves are borne on the stem. They may be alternate (1), opposite (2), spiral (3), whorled (4) or basal (5).

STRUCTURE

The external form of an object (in our case, a botanical object) reveals each aspect of its surfaces and volume but only hints at the internal architecture that provides the object with its 'structural scaffolding'. This interior arrangement can easily be revealed by cutting the fruit or flower under observation, either along its length or across the middle. Often, the inside of an object interests us more than its exterior and is more stimulating.

It is also a good idea, especially when starting the study of a particular flower or other object, to make a quick, perhaps geometrically simplified, diagram of it. For example, on pages 17 and 18 I have drawn some overall views of a gerbera and a cyclamen, as well as some of their details (a leaf, a petal, etc.)

Analytical and comparative studies help in the methodical observation of plants, enabling us to distinguish between their essential and characteristic parts and between features that are general and those that are particular to the specimen in question. Far from being hampered by this approach, artistic drawings will improve, both in simplicity and in precision.

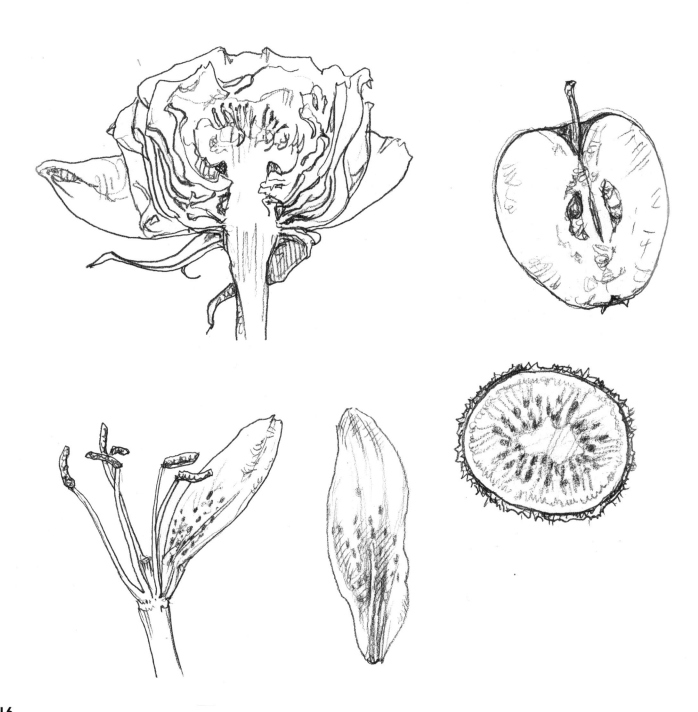

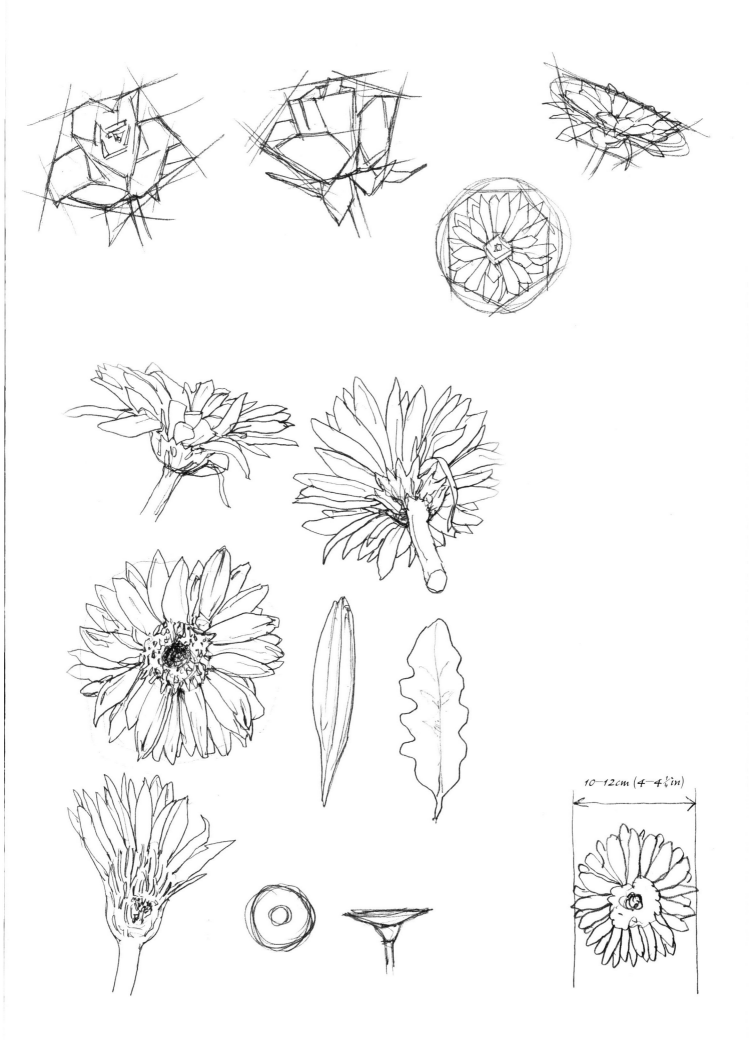

10–12cm (4–4⅛in)

17

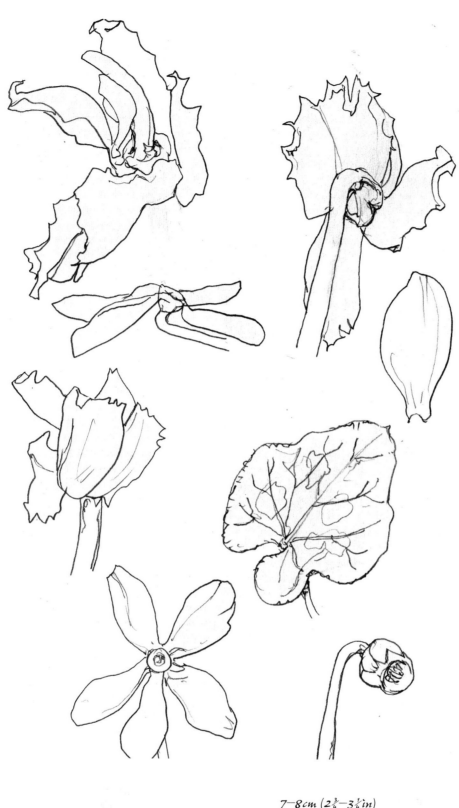

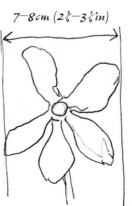

7–8cm (2¾–3¼in)

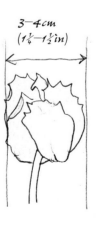

3–4cm
(1¼–1½in)

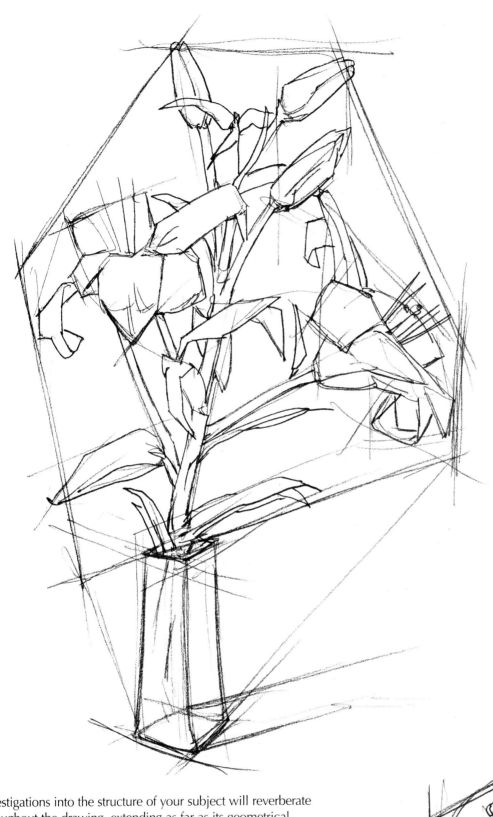

Investigations into the structure of your subject will reverberate throughout the drawing, extending as far as its geometrical structure. There will be a trend to simplify outlines and volumes and reduce them to basic geometric shapes and solids (squares, circles, cubes, spheres, and so on). This process enables you to convey solidity and volume more effectively, aiding you in locating those 'load bearing' structural lines that account for the appearance of substance and depth.

Look at the sketches on this page, for example, and see how the geometrical guidelines and a few intersecting straight lines help to segment the space and facilitate our understanding of the dominant structural tensions within the composition; they also help define the different proportions of each element and of the object as a whole.

LIGHTING

The effects of light and shade created by a source of illumination allow you not only to suggest an object's volume and depth, but also to highlight the various surface characteristics displayed by different flowers, vegetables and fruit, which facilitates their portrayal in drawings and paintings. When making a study of a complex object, such as a group of flowers or unusual vegetables, which requires slow, patient drawing, it is advisable to use artificial lighting (although avoiding multiple light sources), because artificial illumination remains constant over time and is not as variable as sunlight, especially direct sunlight. It is also a worthwhile exercise to study the same object under direct illumination from a single light source while varying the angle from which it is viewed in order to observe the play of light between self-shadow and shadows cast by other objects.

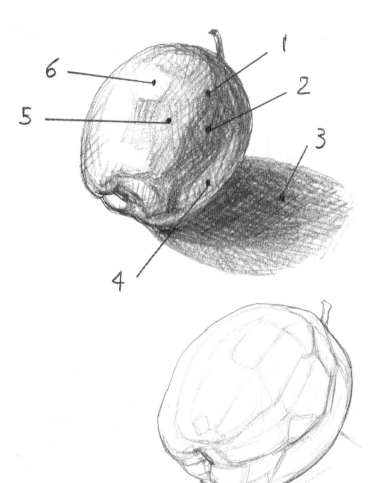

It is helpful to understand the following terms: shadow line, meaning the edge of the shadow (1); self-shadow, which is the shadow cast on an object by itself (2); cast shadow, which is a shadow cast on to another object or surface (3); reflected light (4); penumbra, which is the area where only part of the light source is blocked, the dark part being the umbra (5), and reflection (6).

It is helpful to break down an object into its main tonal 'planes'.

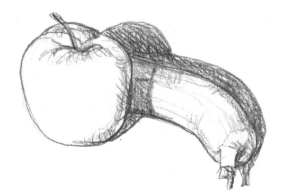

Gradual tonal shading can be simplified by choosing a limited range of tones, (light, mid and dark), which will be sufficient for effective depiction.

Head-on illumination is less suitable for 'artistic' drawings, as it flattens out solid forms, but it is an effective form of lighting for the careful study of profiles.

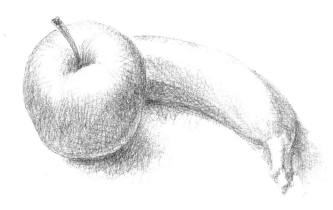

Experiment by viewing the same subject under different lighting conditions:

Diffused daylight.

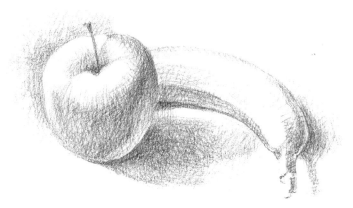

Direct daylight (from a window).

Direct, lateral sunlight (or artificial light).

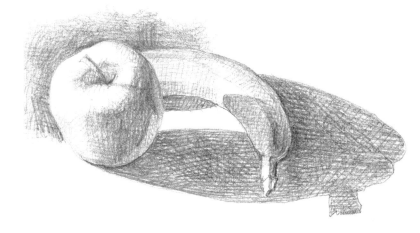

Backlighting by sunlight or artificial light (*contra jour*).

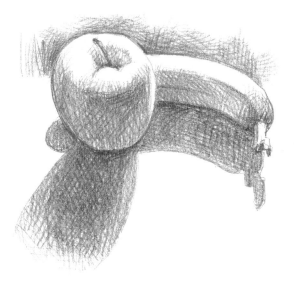

21

STAGES OF A DRAWING

A drawing can be made in various ways and with different intentions or purposes in mind. In terms of the method used, a drawing can be executed using only lines (when setting out to explore nothing but the outlines or contours); using only tones (conveying form and volume solely through tonal graduations between light and shade); or it can combine lines and tones to varying degrees. In terms of intentions or purposes, a drawing may investigate a subject scientifically,

as for a botanical or naturalistic study, or express an emotion or an aesthetic feeling, as in the case of an 'artistic' drawing. The choice of technique, style and depth of analysis depend on the artist's personal style and taste. Nonetheless, out of the many available methods, I suggest a basic and traditional way of proceeding through the stages of a drawing. This method has proved useful because of its huge, almost intuitive simplicity (see pages 23–25).

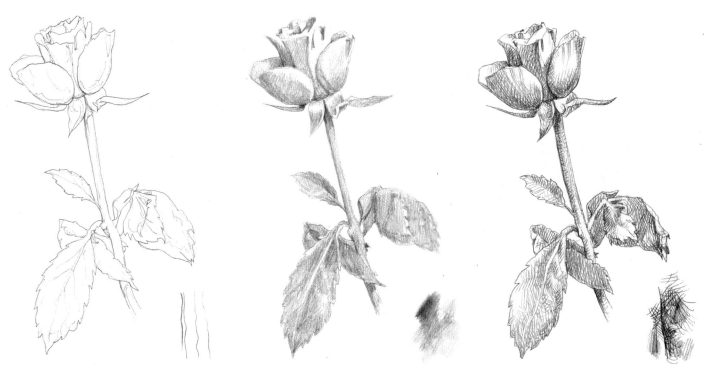

Line drawing.

Tonal drawing.

Combined drawing (shading added to a line drawing).

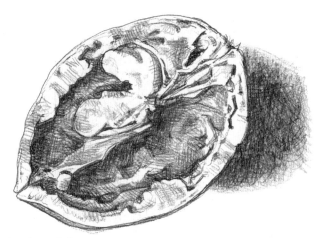

Analytical drawing.

Brief drawing.

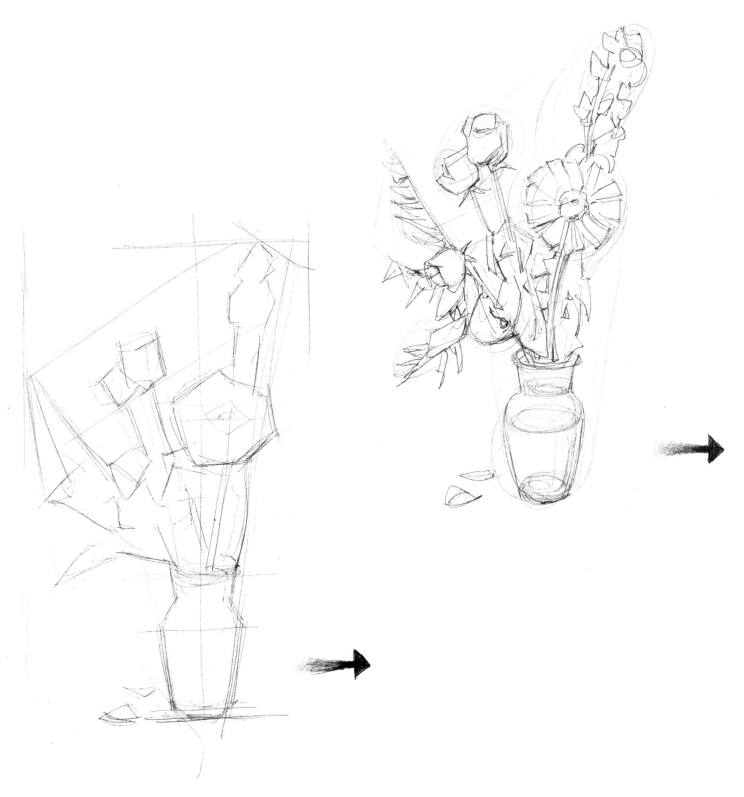

MAKE A DRAWING

1 Make a schematic overview of the whole set-up using light construction lines. You could start by indicating the maximum height and width of the subject (the overall space occupied by the entire composition), followed by a geometric breakdown of the most important features. Although this initial stage may be brief and spontaneous in appearance, it requires great attention because it prepares the basis for the successful execution of the stages that follow.

2 Define the shapes inside the 'structural scaffolding' using segmented lines, paying attention, above all, to setting out the exact dimensions, the correct relationships between the individual elements of each flower, and the perspective view of the vase.

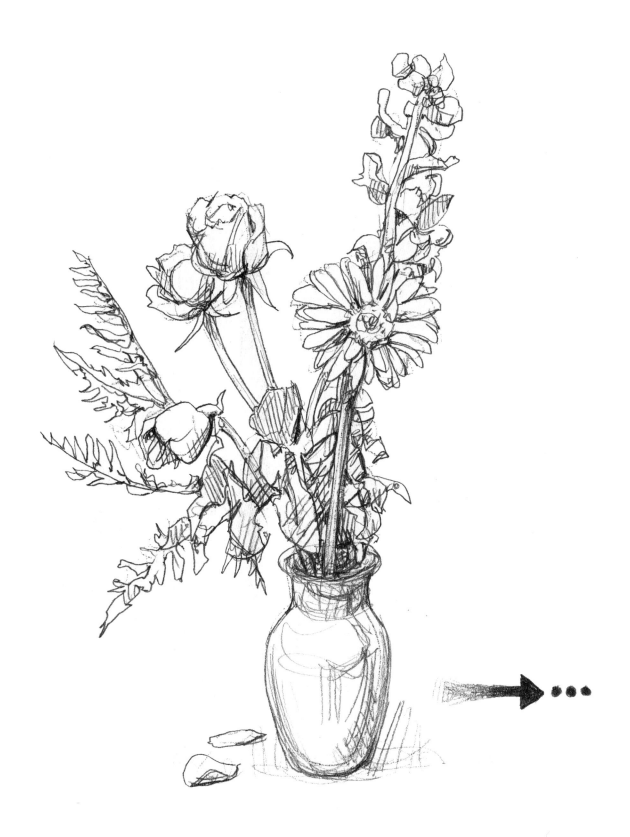

3 Working across the whole of the composition simultaneously, complete the schematic sketches of the previous stage with the actual forms of each flower and leaf, paying careful attention to proportion. Add the larger, deeper areas of shade. After this, you could go on to elaborate the detail further and work on the tonal differences, depending on your style, until you are happy with the final effect.

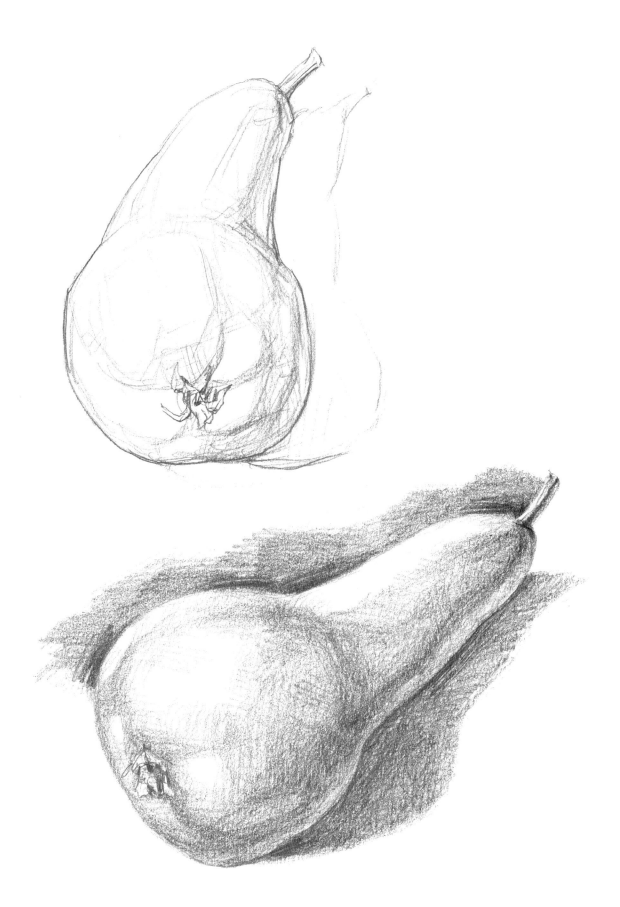

When you draw very simple, compact shapes, the benefits of starting with steps 1 and 2 (see page 23) become more evident, particularly in the case of large fruits. The linear, construction stage, which is based on a cognitive treatment of the object, can be developed to provide an investigation into the form's 'architecture'. Alternatively, the construction stage can be developed into a tonal drawing, perhaps combining visual realism and emotion, in which case the linear drawing provides the underlying support of the finished work.

BOTANICAL SKETCHBOOK: FLOWERS

In these final three sections I have gathered many pages from a sketchbook of mine, which I recently dedicated to botanical subjects that are easy to come across in our daily lives. These drawings have been executed quite quickly and fairly freely, and I have concentrated on the form and the overall characteristics of the object concerned – a flower, fruit or a vegetable – as well as on some of its more important details, or simply on details that I found interesting. Some of these explorations have been conducted from unusual viewpoints.

I used a sketchbook measuring 15 × 18cm (6 × 7in) with pages of fairly smooth, white paper and a mechanical pencil with a fine (0.5mm / ¼in) HB lead.

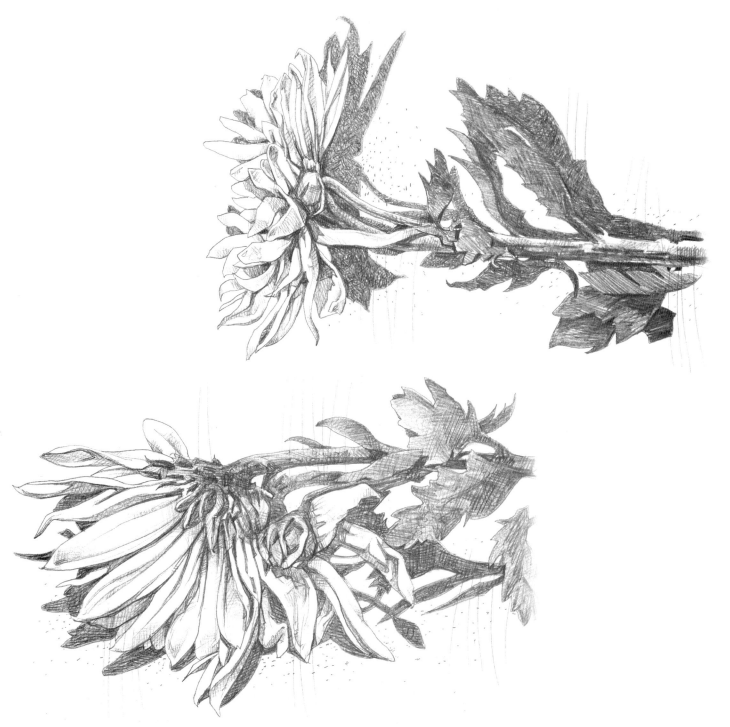

Here, the flower's shadow, cast on to the surface underneath, creates a densely packed, maze-like pattern made up of tiny patches of light and shade. This provided an opportunity for a somewhat unusual graphic study (which, at first glance, may be a little difficult to interpret).

Chrysanthemums originated in Asia, but have now spread all over the world. There are about 30 varieties, most reaching between 50cm (19½in) and 70cm (27½in) in height and they come in a large range of colours: pink, white, yellow, red, violet, etc. The petals are very long and narrow, and radiate outwards as on a daisy. The leaves are long and lobed.

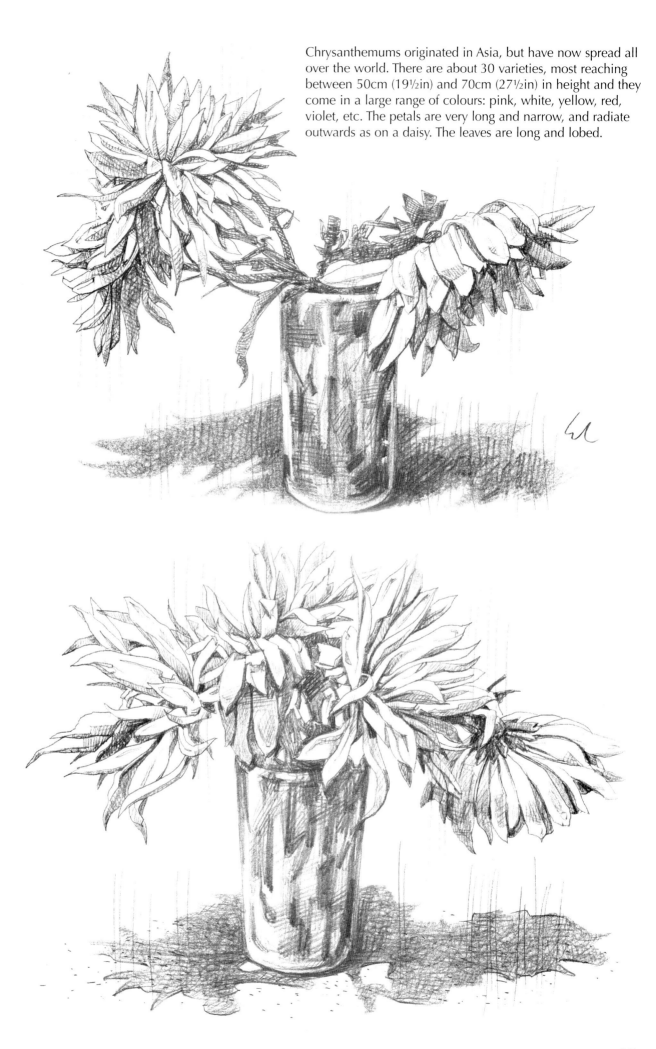

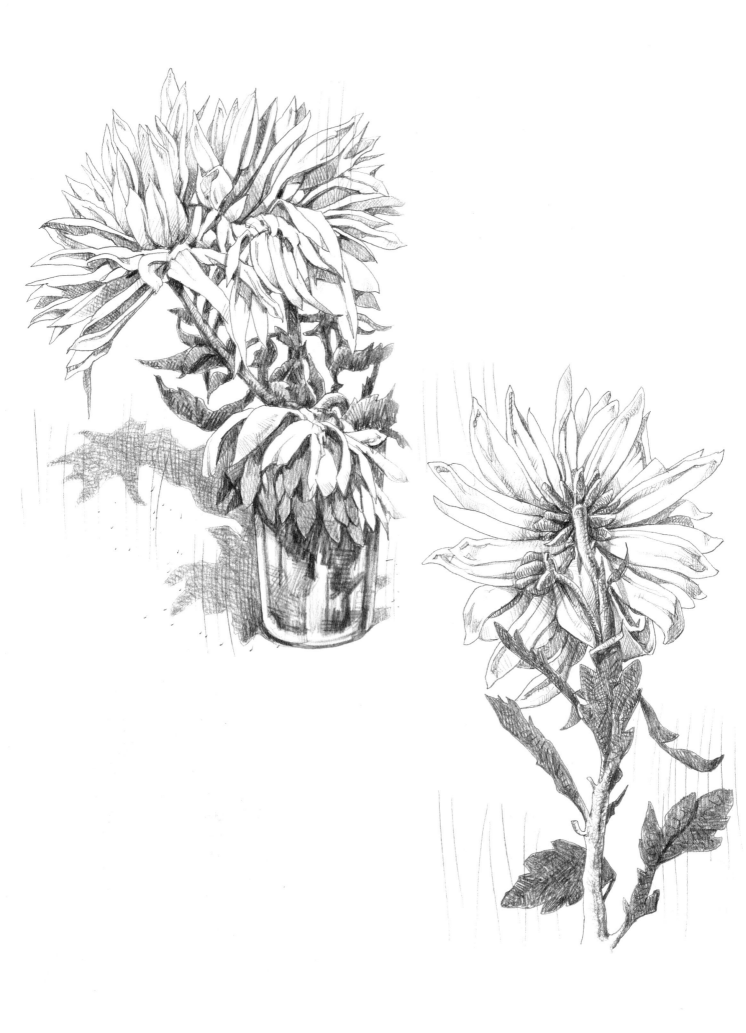

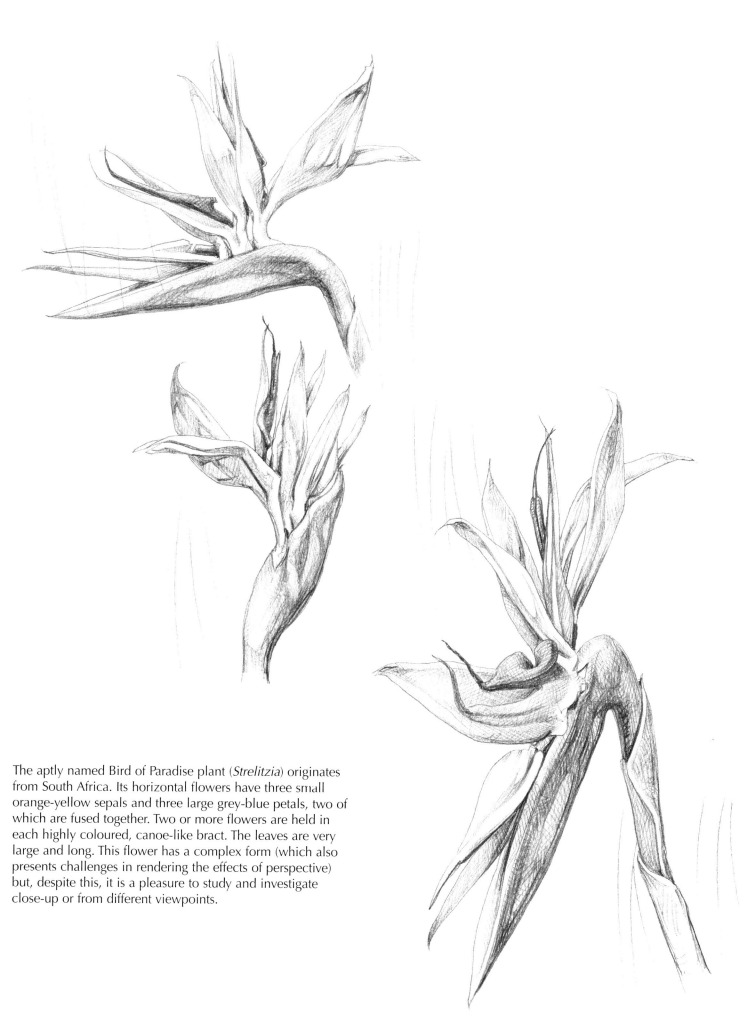

The aptly named Bird of Paradise plant (*Strelitzia*) originates from South Africa. Its horizontal flowers have three small orange-yellow sepals and three large grey-blue petals, two of which are fused together. Two or more flowers are held in each highly coloured, canoe-like bract. The leaves are very large and long. This flower has a complex form (which also presents challenges in rendering the effects of perspective) but, despite this, it is a pleasure to study and investigate close-up or from different viewpoints.

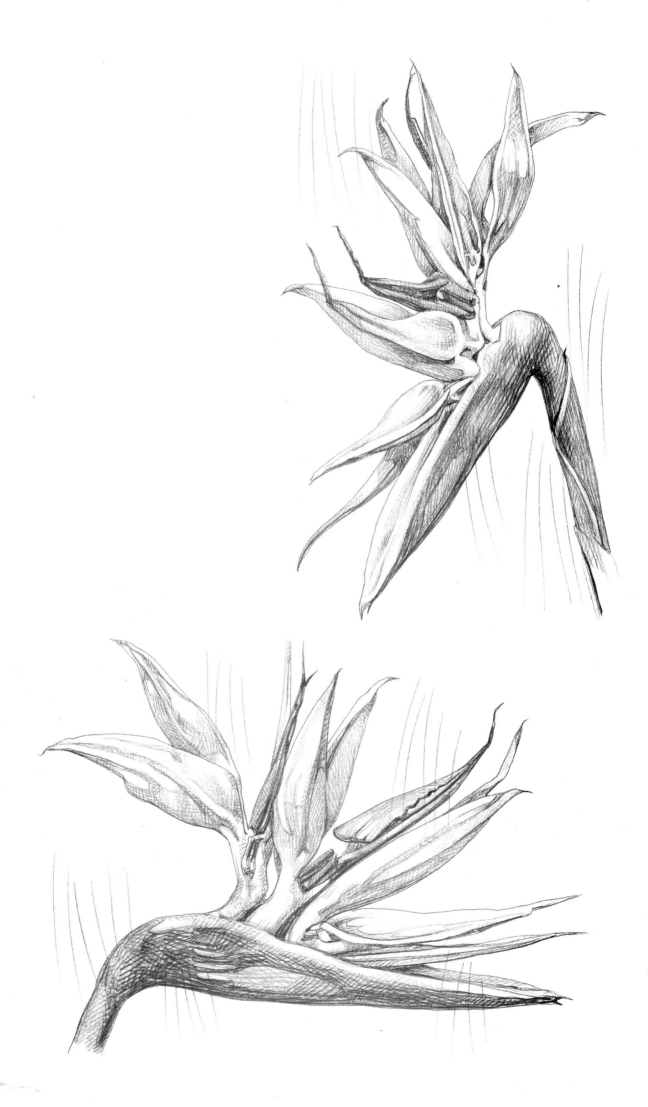

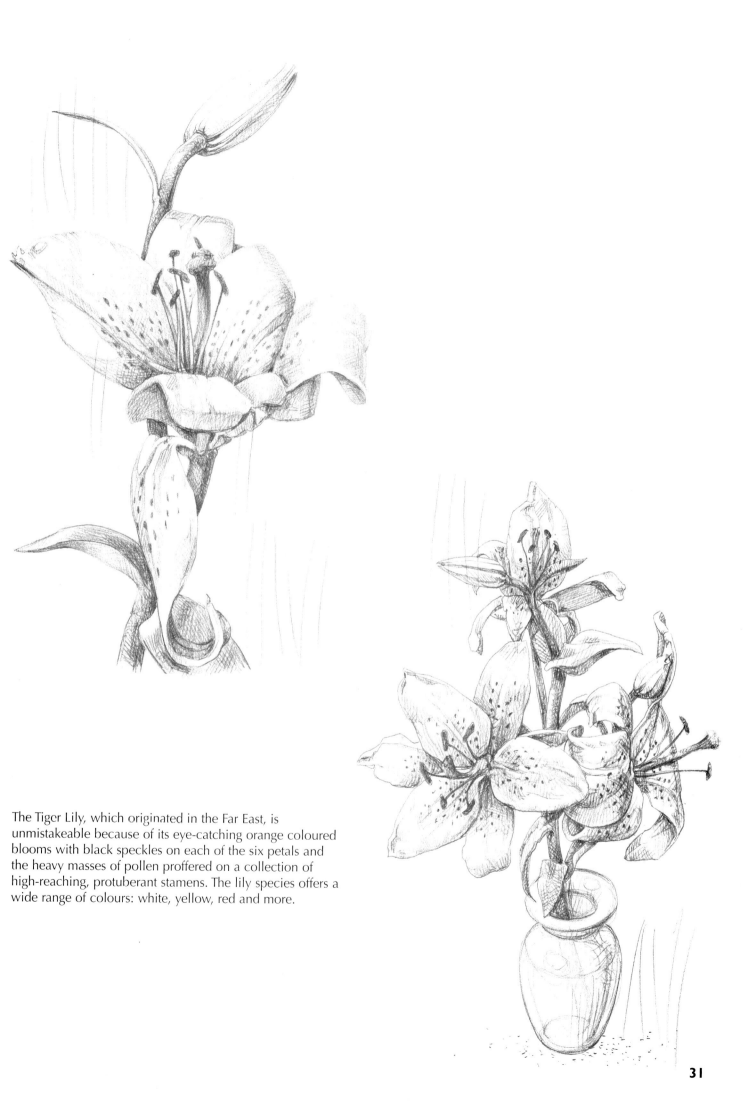

The Tiger Lily, which originated in the Far East, is unmistakeable because of its eye-catching orange coloured blooms with black speckles on each of the six petals and the heavy masses of pollen proffered on a collection of high-reaching, protuberant stamens. The lily species offers a wide range of colours: white, yellow, red and more.

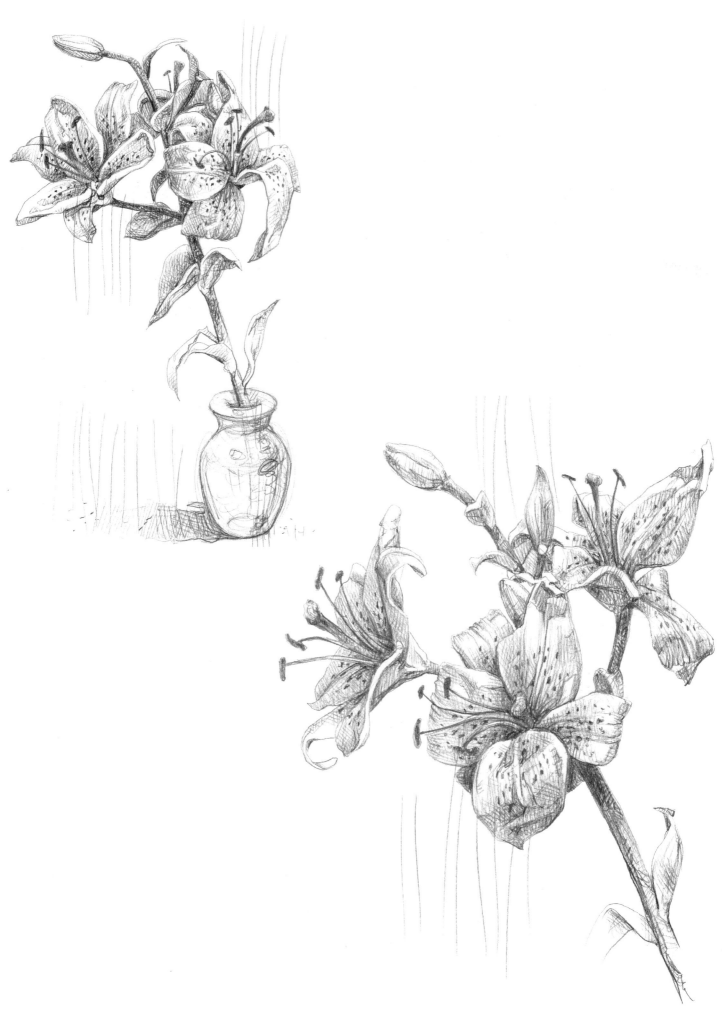

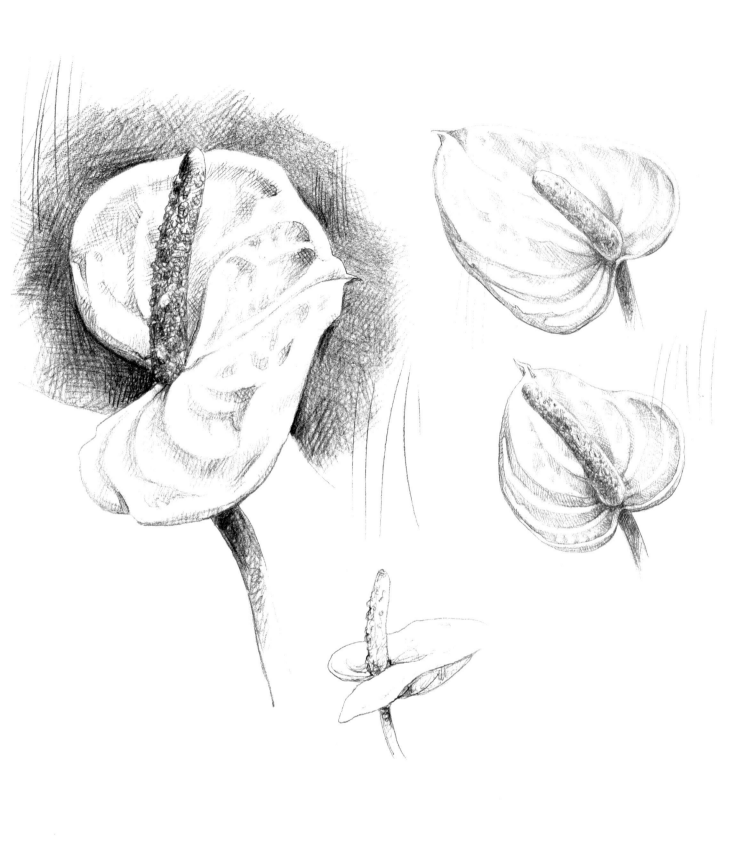

The Flamingo Lily (*Anthurium*), which originates from tropical zones, is a bloom that is divided into two parts: the smooth, waxy, heart-shaped and flattened spathe (a bract or leaf that encloses the flower before it blooms), which can be white or red in colour and is fairly bulky in its proportions, and the spadix (a spongy-looking cylindrical structure which forms a continuation of the stalk and where, believe it or not, the real flowers grow). It is a flower that has the appearance of being almost artificial, as if it were made of plastic, and this characteristic makes it well suited to graphic studies of its various surfaces and their reflections.

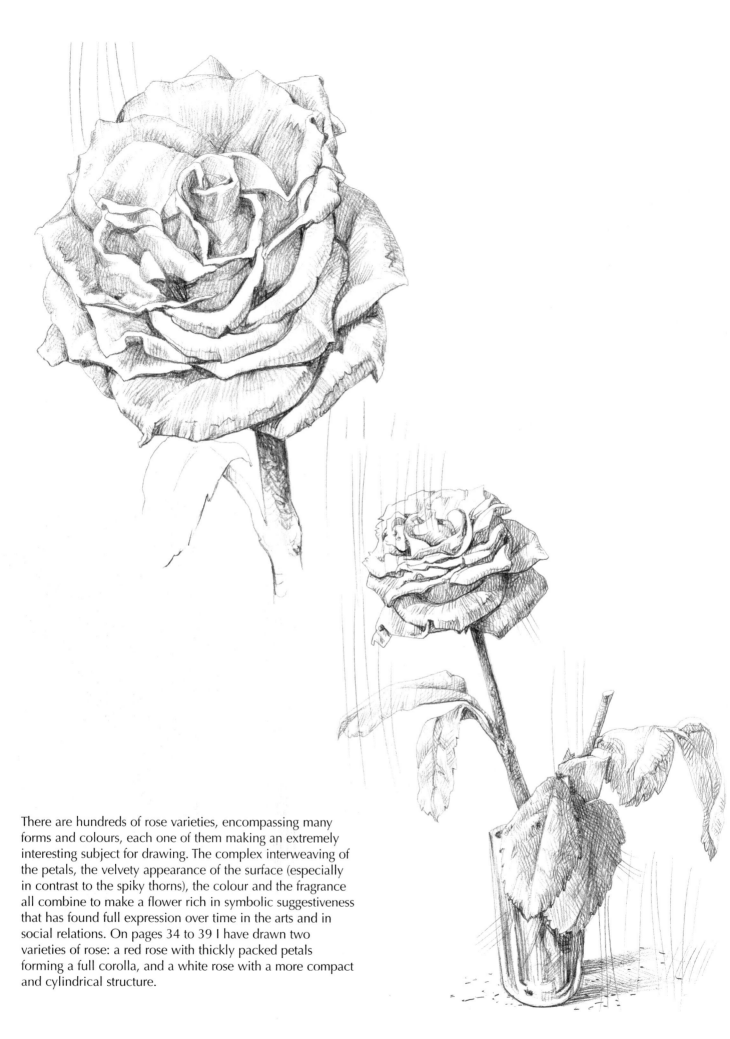

There are hundreds of rose varieties, encompassing many forms and colours, each one of them making an extremely interesting subject for drawing. The complex interweaving of the petals, the velvety appearance of the surface (especially in contrast to the spiky thorns), the colour and the fragrance all combine to make a flower rich in symbolic suggestiveness that has found full expression over time in the arts and in social relations. On pages 34 to 39 I have drawn two varieties of rose: a red rose with thickly packed petals forming a full corolla, and a white rose with a more compact and cylindrical structure.

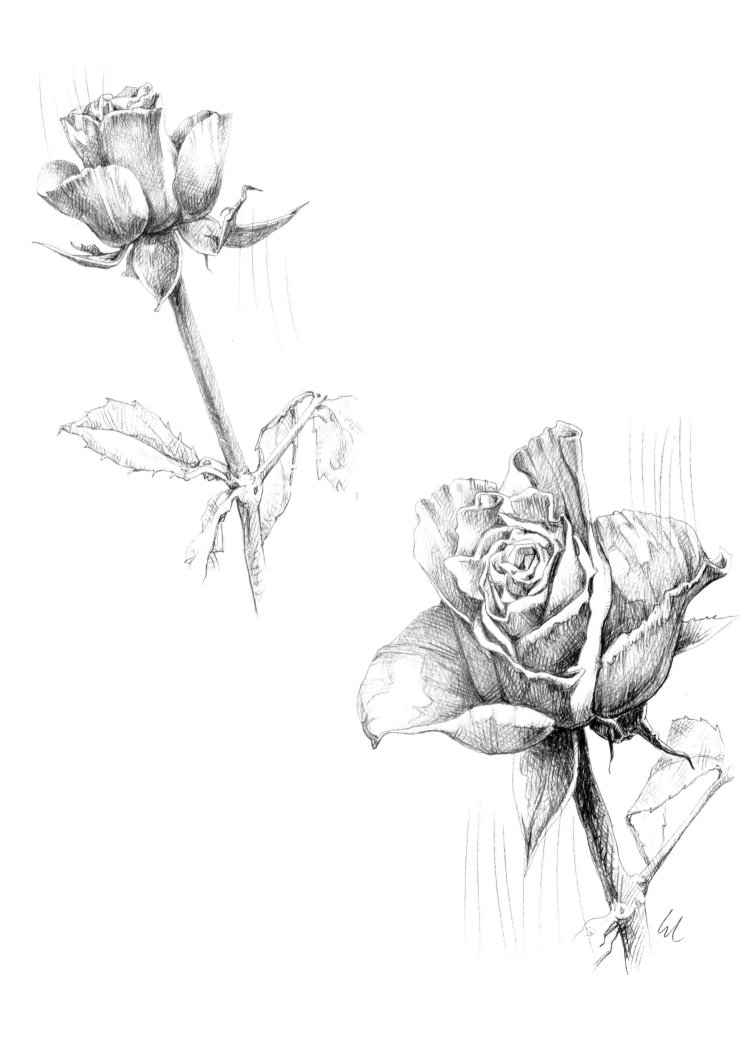

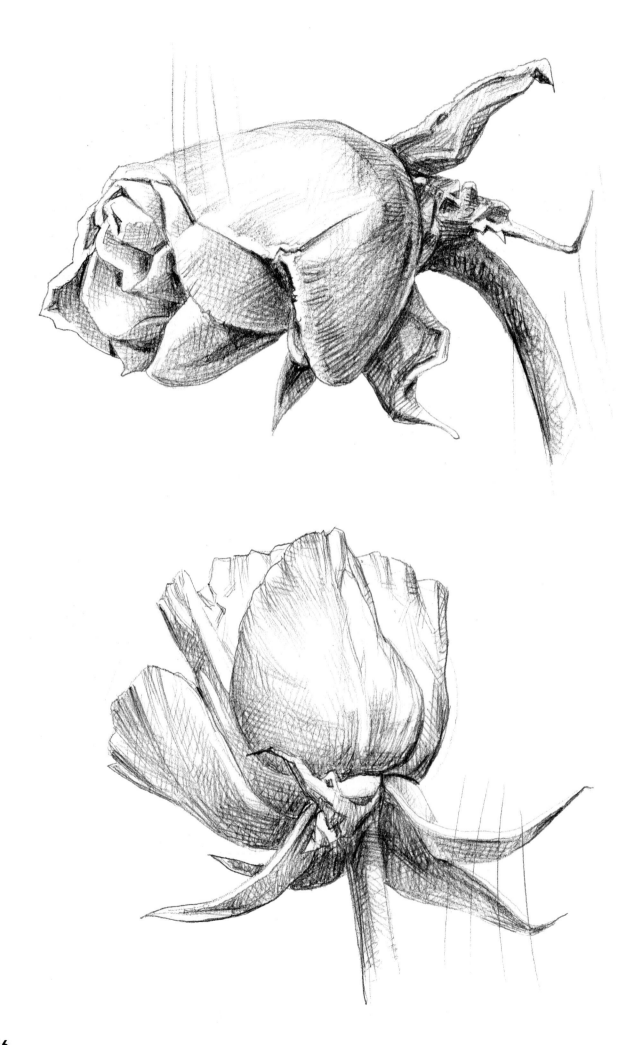

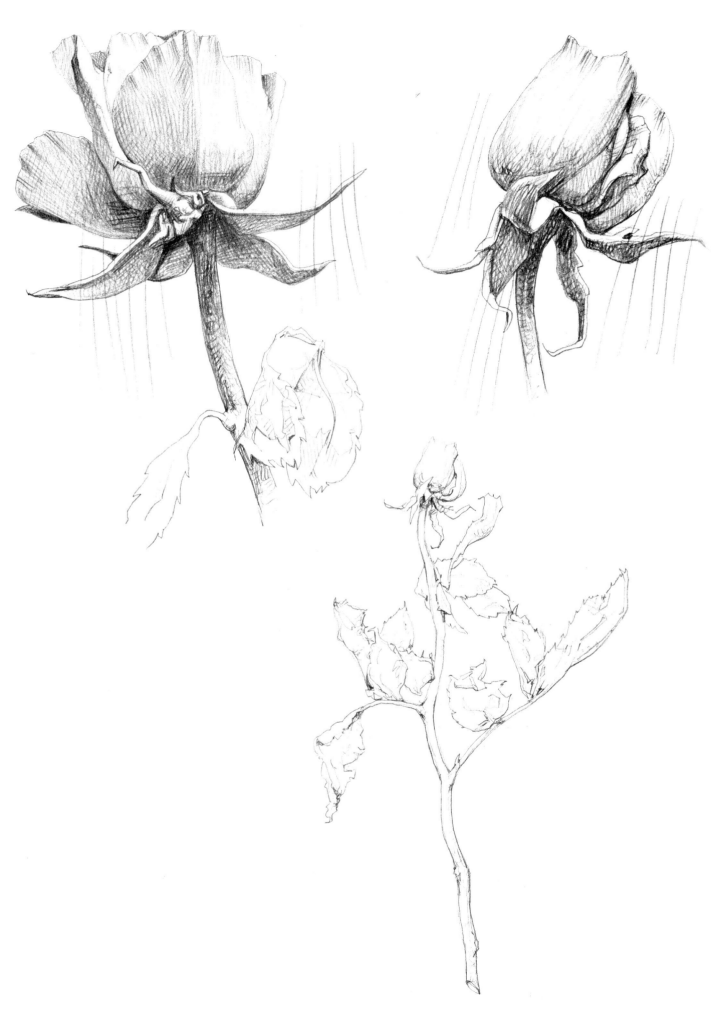

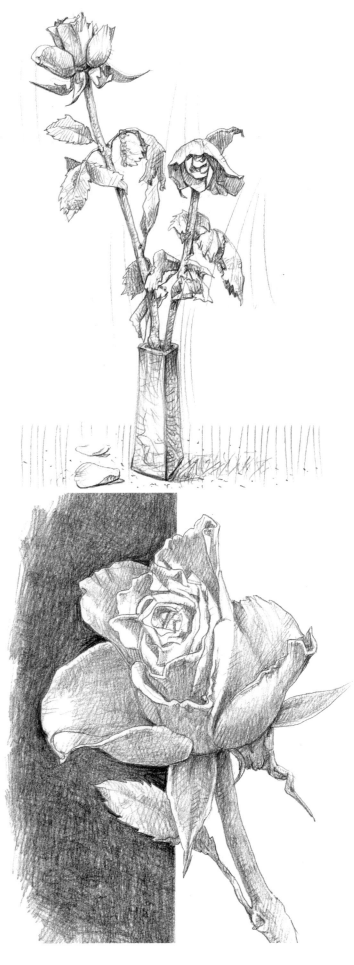

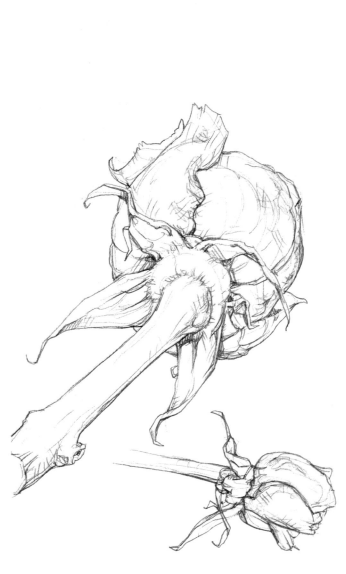

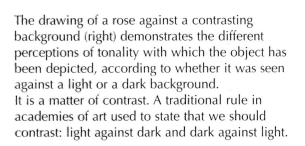

The drawing of a rose against a contrasting background (right) demonstrates the different perceptions of tonality with which the object has been depicted, according to whether it was seen against a light or a dark background.

It is a matter of contrast. A traditional rule in academies of art used to state that we should contrast: light against dark and dark against light.

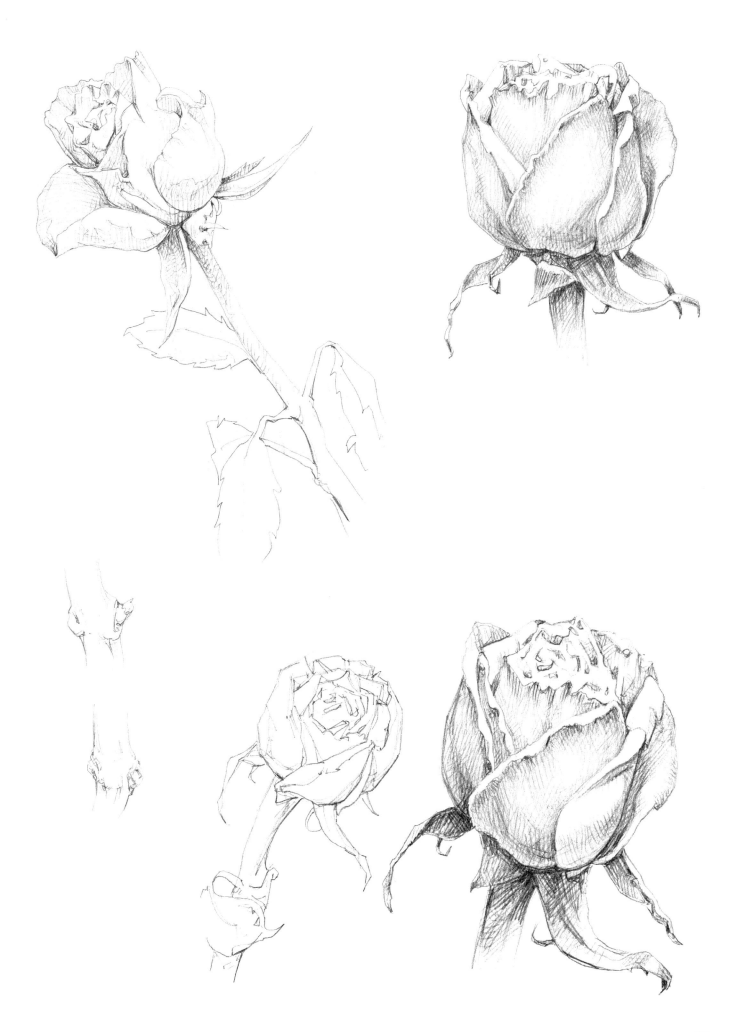

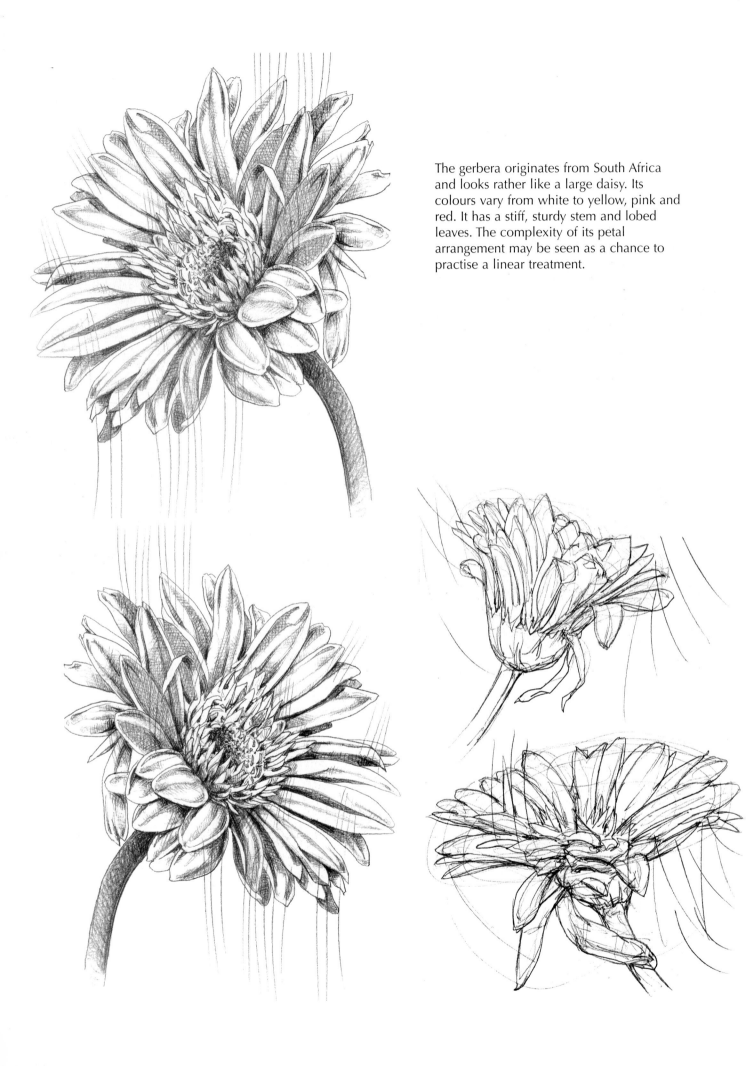

The gerbera originates from South Africa and looks rather like a large daisy. Its colours vary from white to yellow, pink and red. It has a stiff, sturdy stem and lobed leaves. The complexity of its petal arrangement may be seen as a chance to practise a linear treatment.

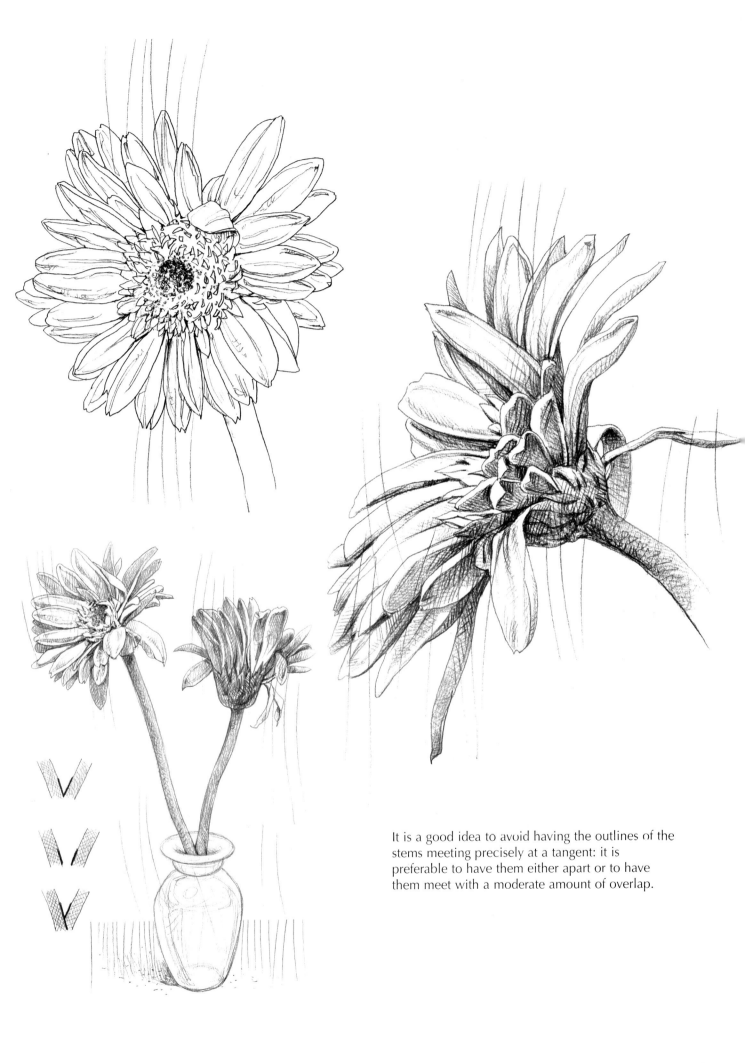

It is a good idea to avoid having the outlines of the stems meeting precisely at a tangent: it is preferable to have them either apart or to have them meet with a moderate amount of overlap.

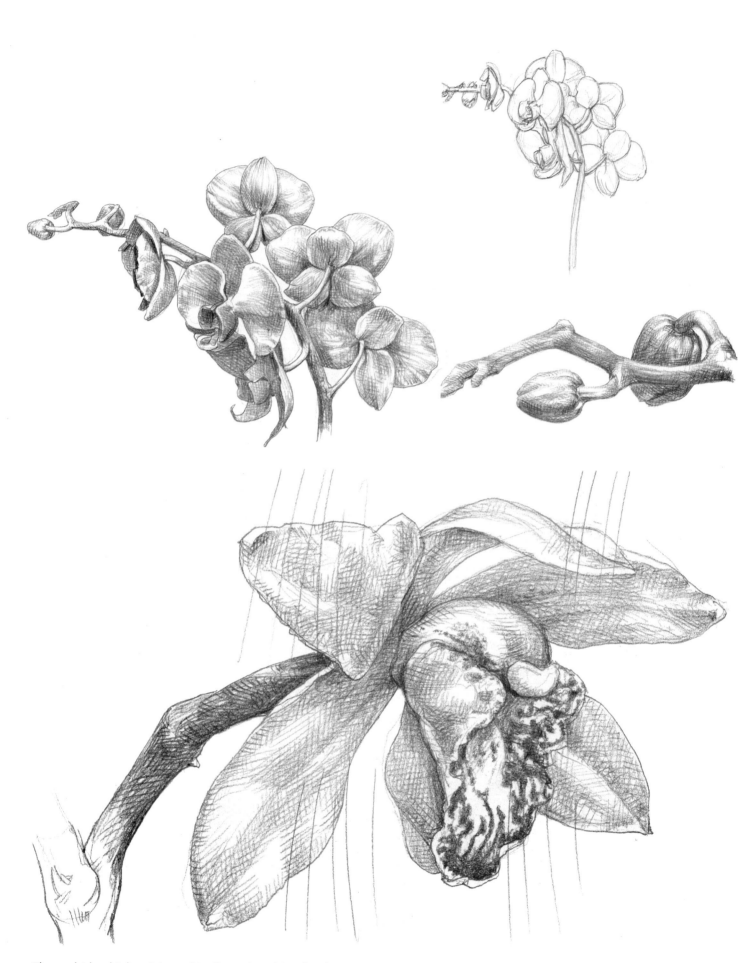

The orchid, which originated in Central and South Africa, has many beautiful varieties. In the drawings at the top of this page I have shown a type of orchid with a small corolla. The flower comprises three sepals and three petals which resemble each other in both shape and size, with the exception of one (the labellum), which looks strikingly different. The corolla is borne on a sturdy stalk and it is turned through 90°, so that it faces out horizontally.

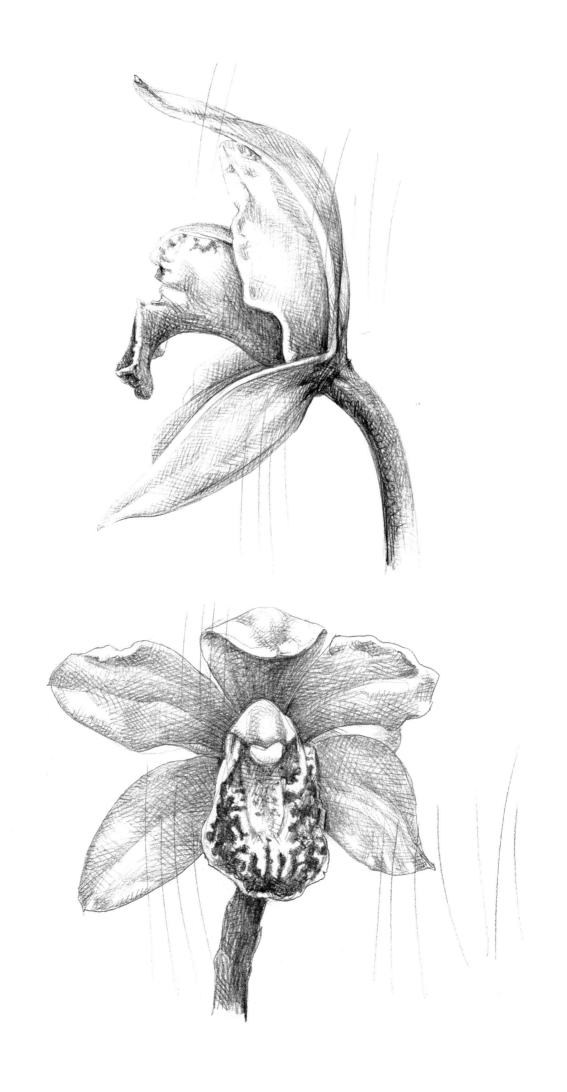

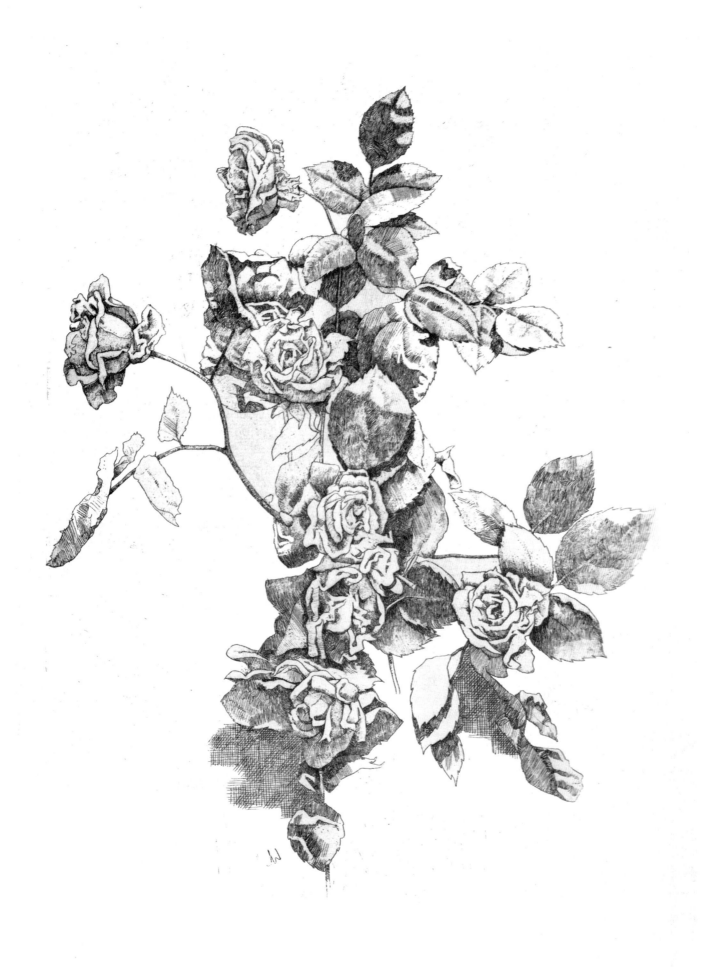

Roses from my Garden (1984), etching, 227 × 293mm (9 × 11½in).

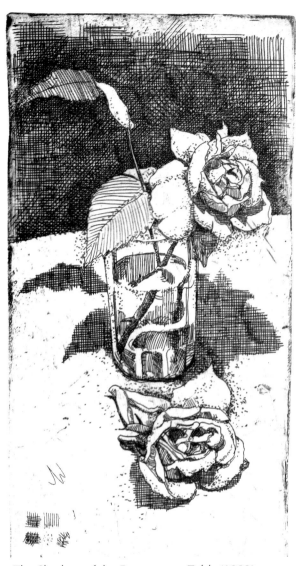

The Shadow of the Rose on my Table (1983), etching, 95 × 195mm (3¾ × 7¾in).

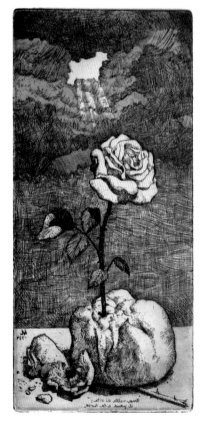

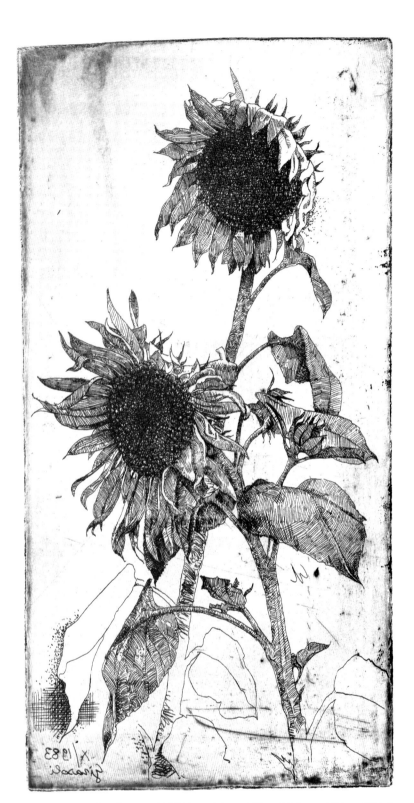

Sunflowers (1983), etching, 117 × 234mm (4½ × 9¼in).

The Bread and the Rose (1984), etching, 70 × 152mm (2¾ × 6in).

BOTANICAL SKETCHBOOK: FRUIT

A fruit results from the development of what was the female portion of the flower as it envelops the seeds. Fruit may be divided into dry and fleshy fruits. The latter are rich in soft or juice-laden flesh and can be further divided into categories such as berries, drupes (stone fruit such as plums) and others. Dry fruits have a hard outer wall and may also be sub-divided into dehiscent, in which the fruit splits open as in legumes such as peas, and indehiscent, in which the fruit does not split as with nuts and grains. Unless your interest lies in making scientific drawings, you will not require an in-depth knowledge of botany in order to draw these subjects, but it is a fascinating and appealing subject that will complement your general education. These pages focus on the variety of structures, shapes and colours displayed by some of the more common fruits that are found on our dining tables. In fact, most of the drawings that follow were made either during or after a meal.

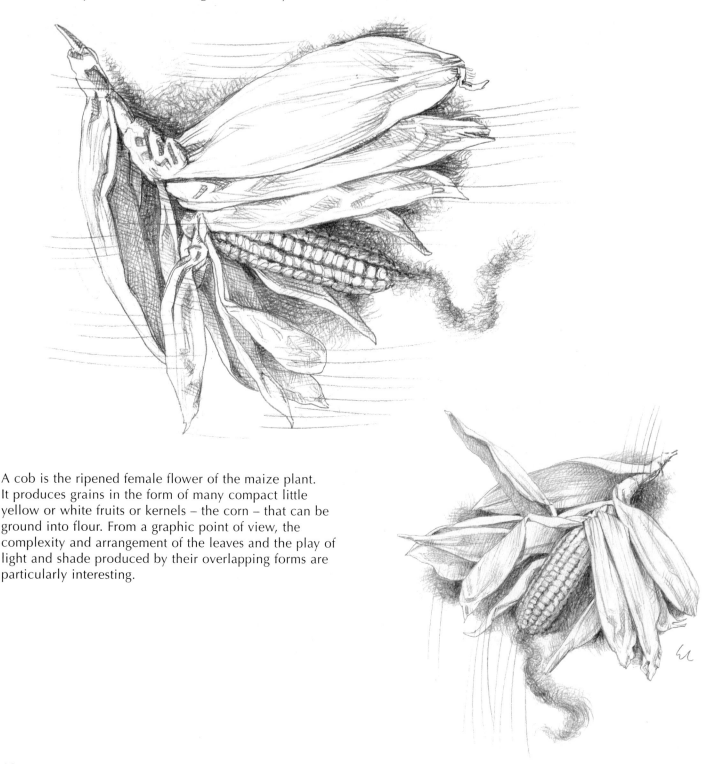

A cob is the ripened female flower of the maize plant. It produces grains in the form of many compact little yellow or white fruits or kernels – the corn – that can be ground into flour. From a graphic point of view, the complexity and arrangement of the leaves and the play of light and shade produced by their overlapping forms are particularly interesting.

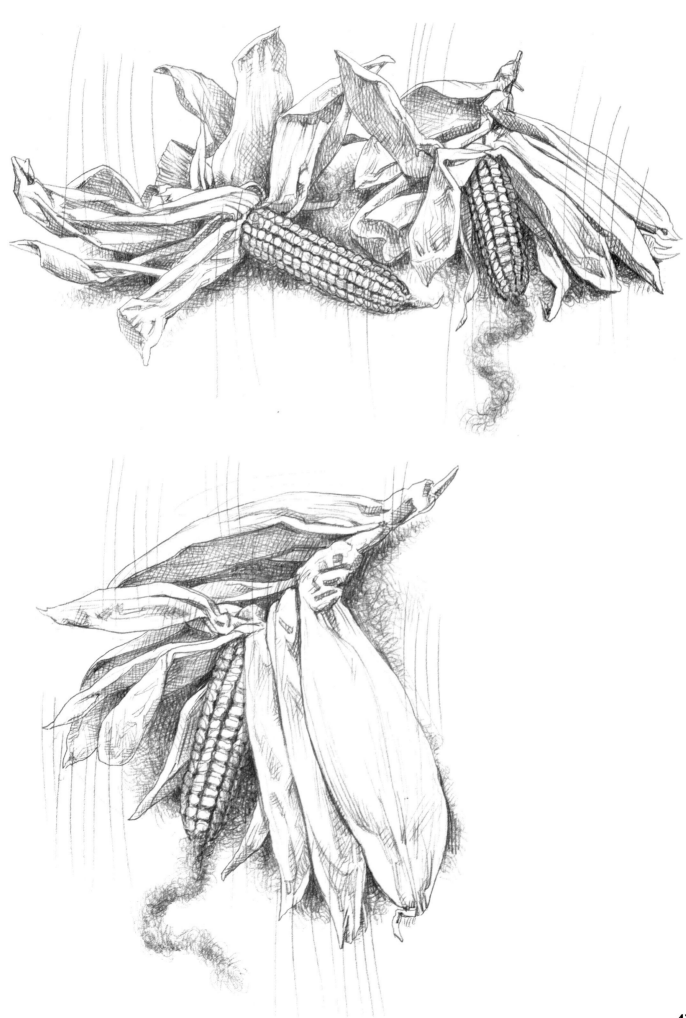

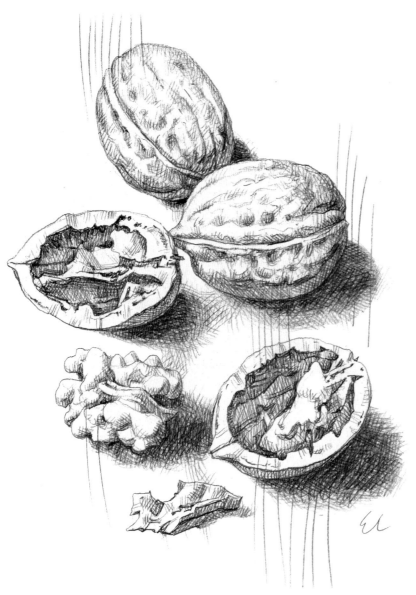

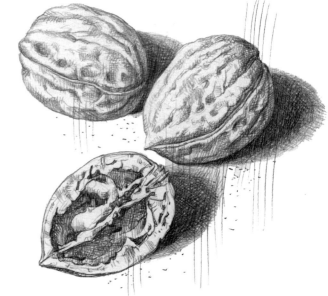

Here, and on the following pages, are a number of drawings of common fruits. They are listed here in the order in which they are shown: walnuts, pomegranates, mandarins, kiwi, chestnuts, pears, grapes and bananas. I studied the overall shape as well as particular details of each one, its internal structure, etc., concentrating in particular on the various characteristics of the external surface (whether it is smooth and shiny, gnarled, granular, furry, etc.), and on the details of the interior organisation as revealed when the fruit is cut open. When carefully observed from close up, these fruits take on forms of unsuspected complexity and beauty.

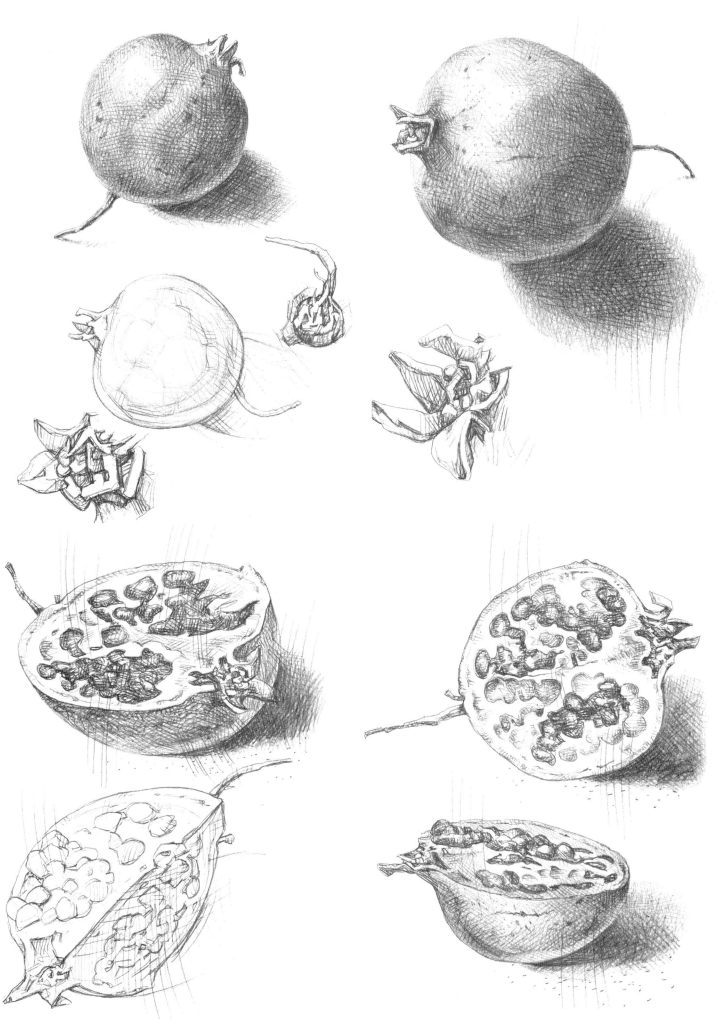

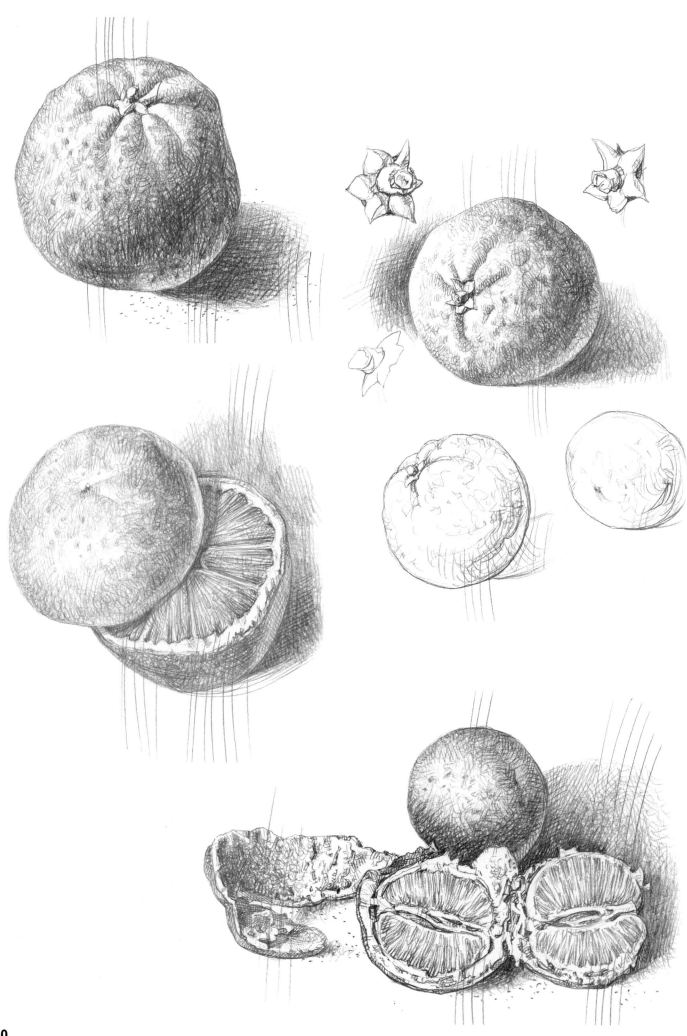

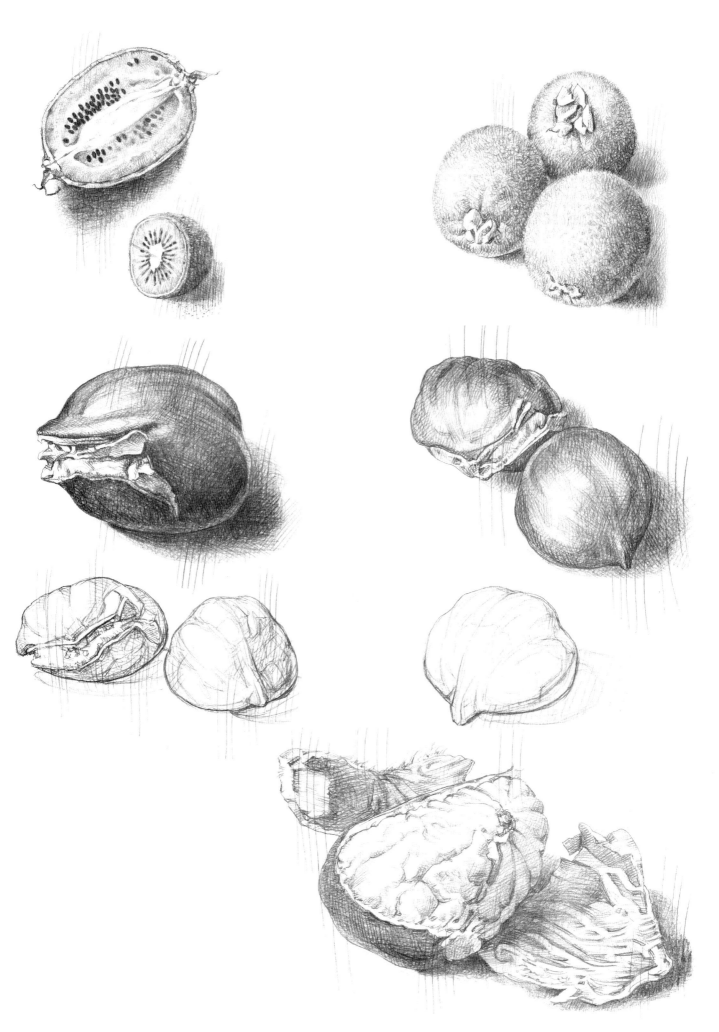

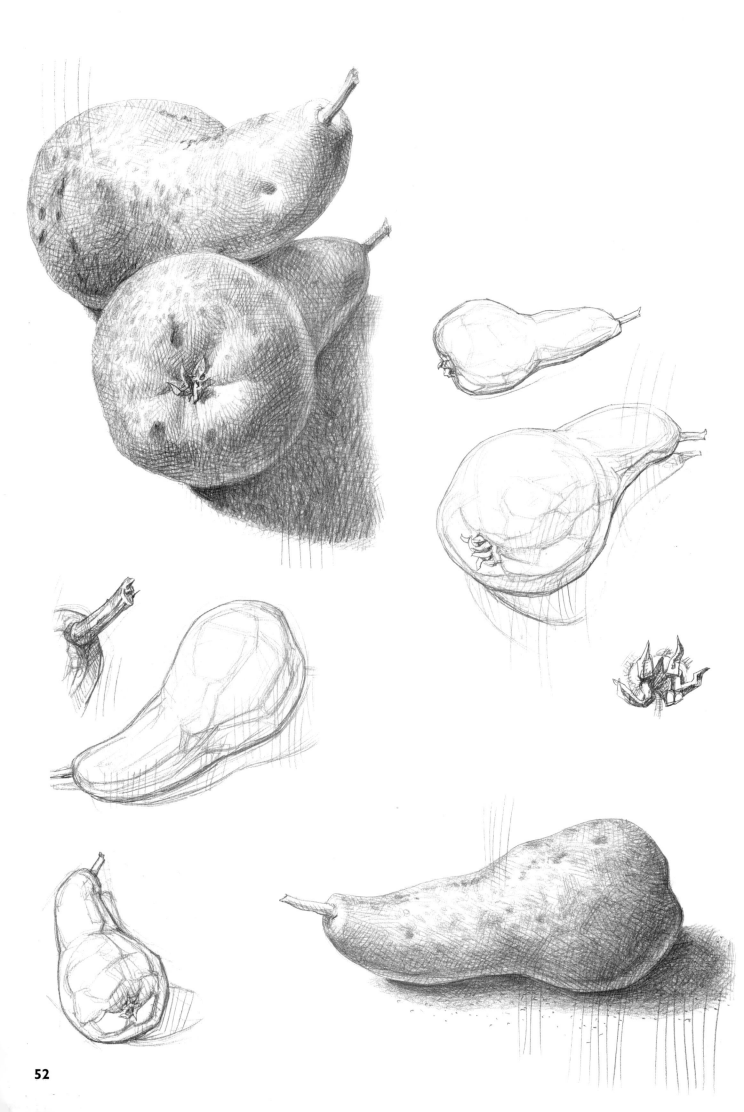

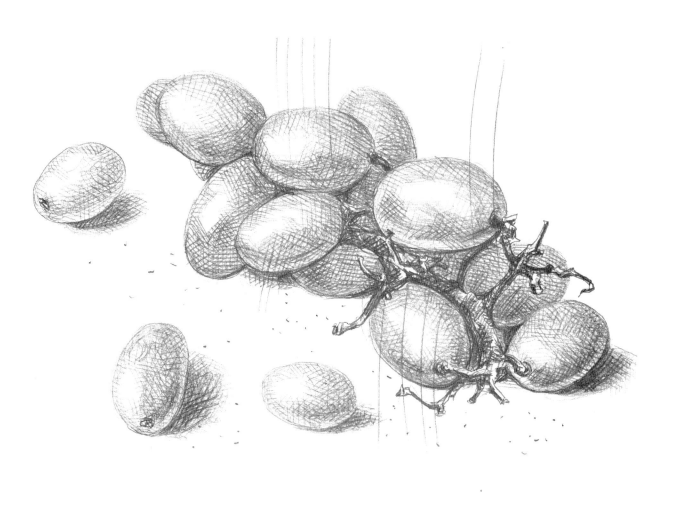

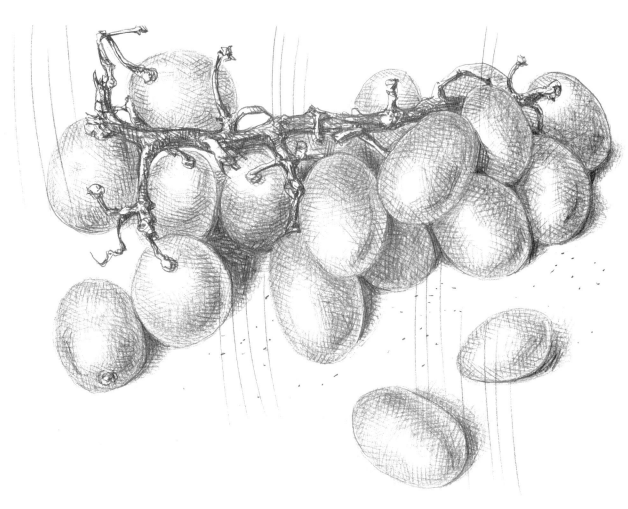

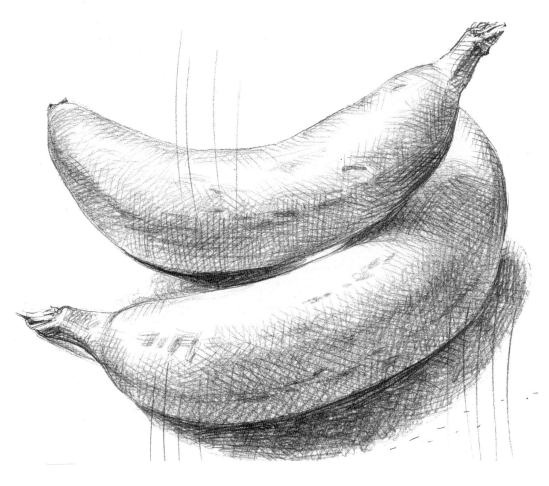

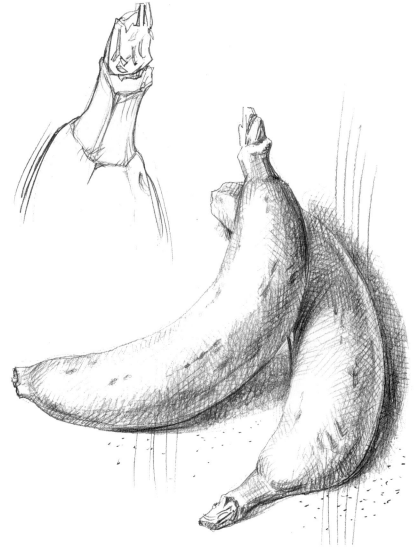

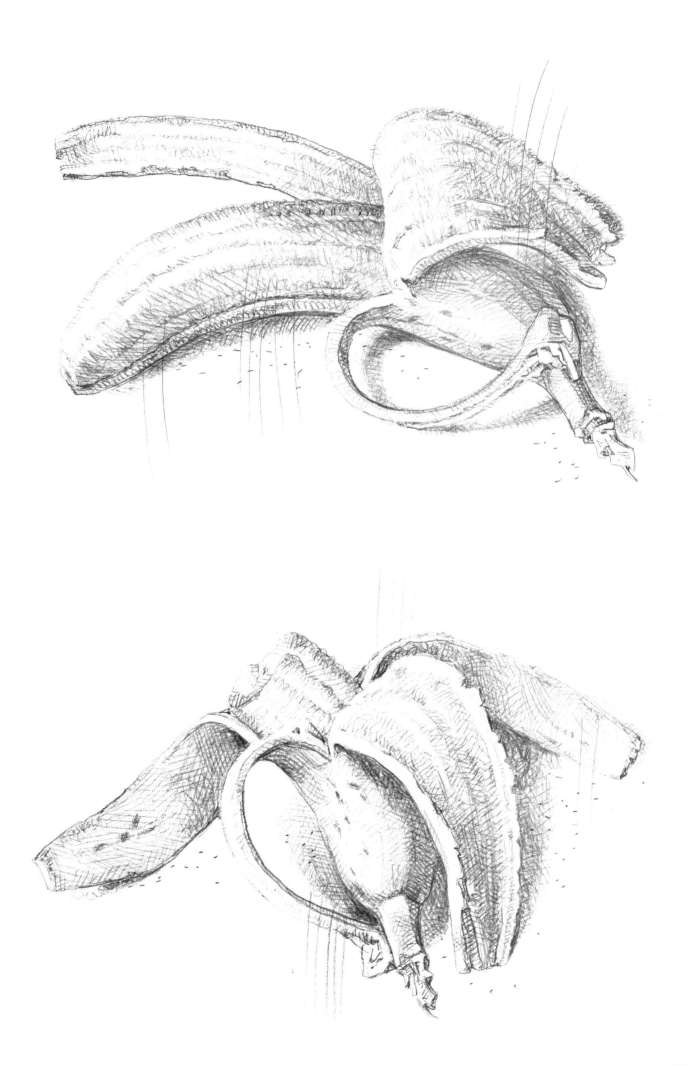

BOTANICAL SKETCHBOOK: VEGETABLES

In this final section, I have portrayed some easily available vegetables that are well known to us all. 'Vegetables' is the general term for herbaceous plants that are cultivated for their edible leaves, roots, tubers, bulbs, fruit or seeds. There are numerous varieties of each, all of them rich in graphic or sculptural interest due to shapes that are often complex and surprising. Even more so than the fruits examined in the previous section, vegetables offer many opportunities for making either rapid sketches or an elaborate study.

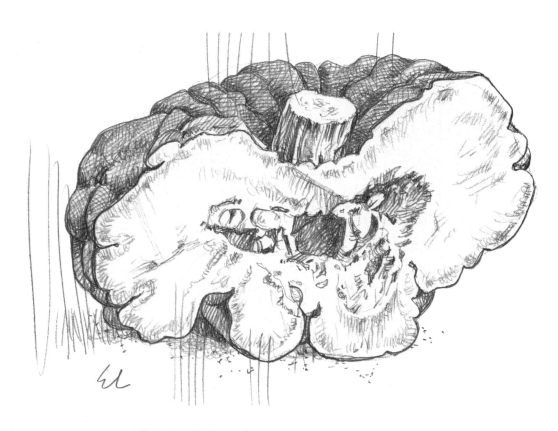

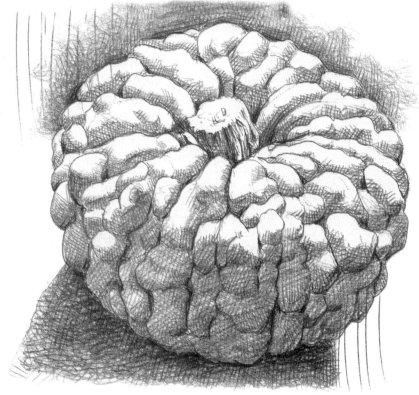

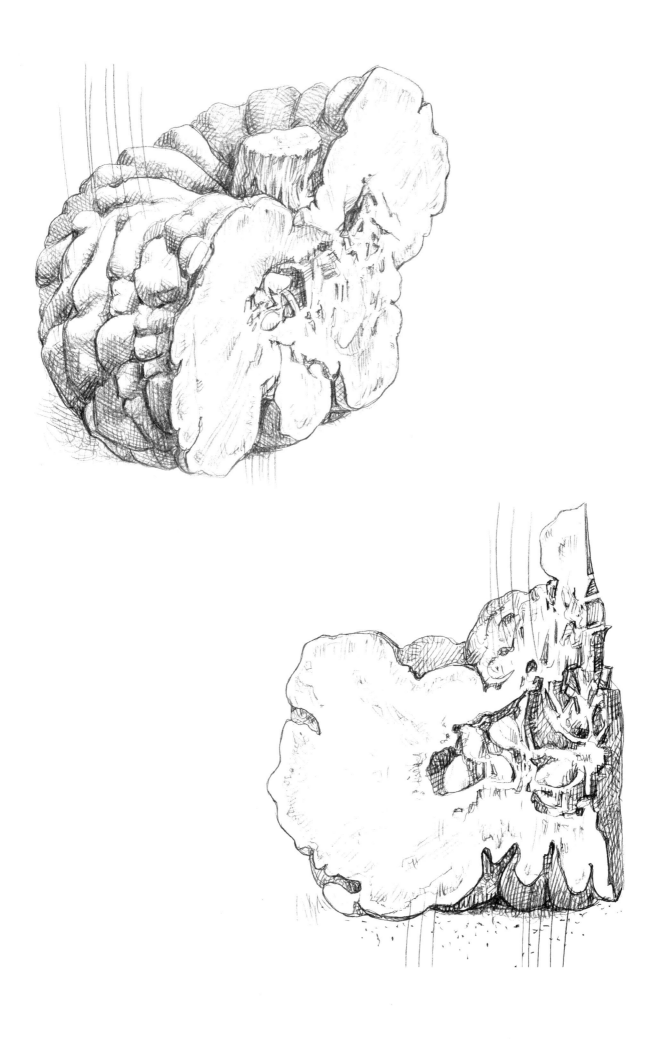

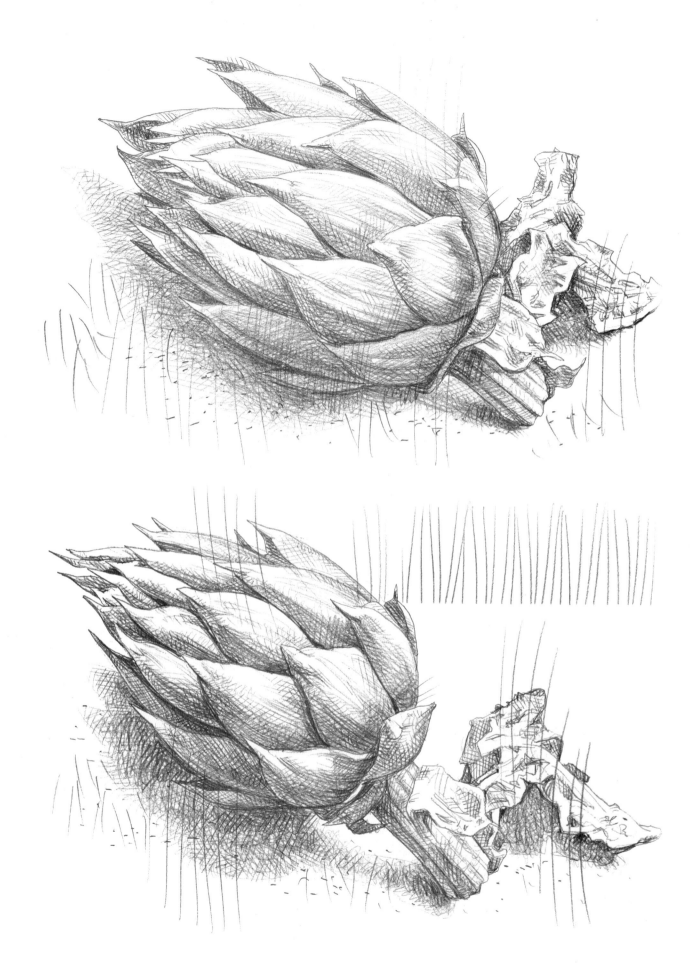

The spiked 'leaves' of the globe artichoke are almost geometrically arranged, overlapping like tiles on a roof. They are somewhat convex in form, which means each one of them produces a play of light, shade and reflection which, although subordinate in effect to that of the overall form of the vegetable, should not be overlooked.

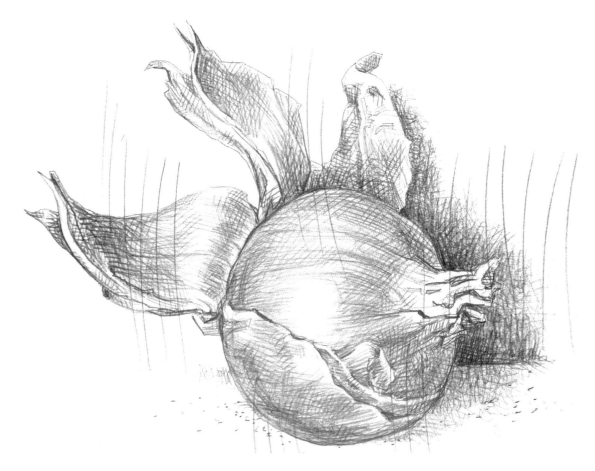

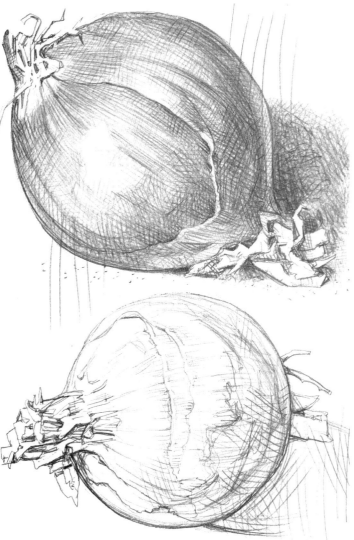

The golden onion (*Cipolla dorata*) has a crisp, fleshy bulb made up of very fine overlapping layers of skin. The shiny surfaces give off bright reflections that help to draw our attention to the characteristic linear markings of the outer layers.

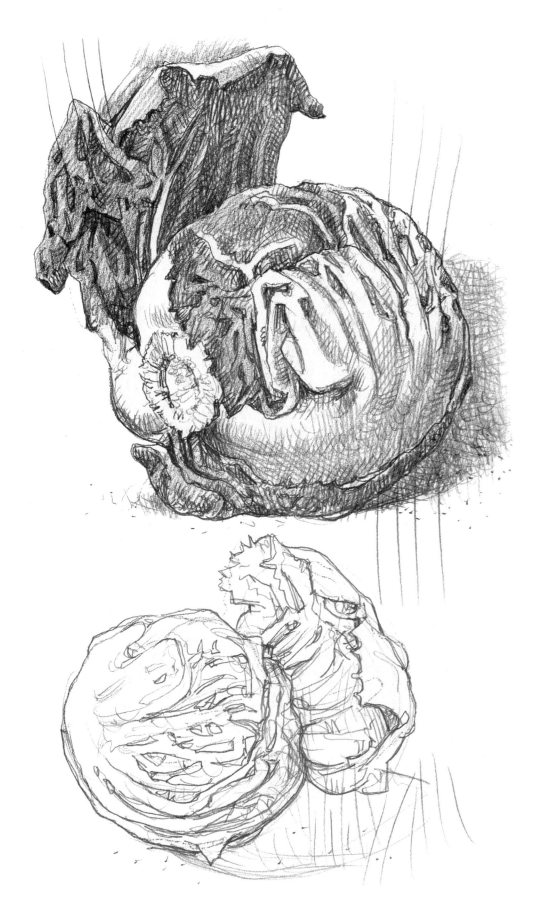

Red chicory (*Radicchio*) is a roundish, compact, richly veined plant with closely overlapping layers of leaves whose intricate labyrinthine arrangement becomes fully apparent when it is sliced in half. When you draw this kind of interweaving pattern, it is important not to get confused or lost in the complex twists and turns. Ideally, patiently follow the path of one meandering line at a time, and compare it along the way with its neighbour. This operation becomes easier if you begin from the central area and work outwards towards the perimeter. As long you work conscientiously, and faithfully depict what is in front of you, there is no need to draw absolutely everything that you see.

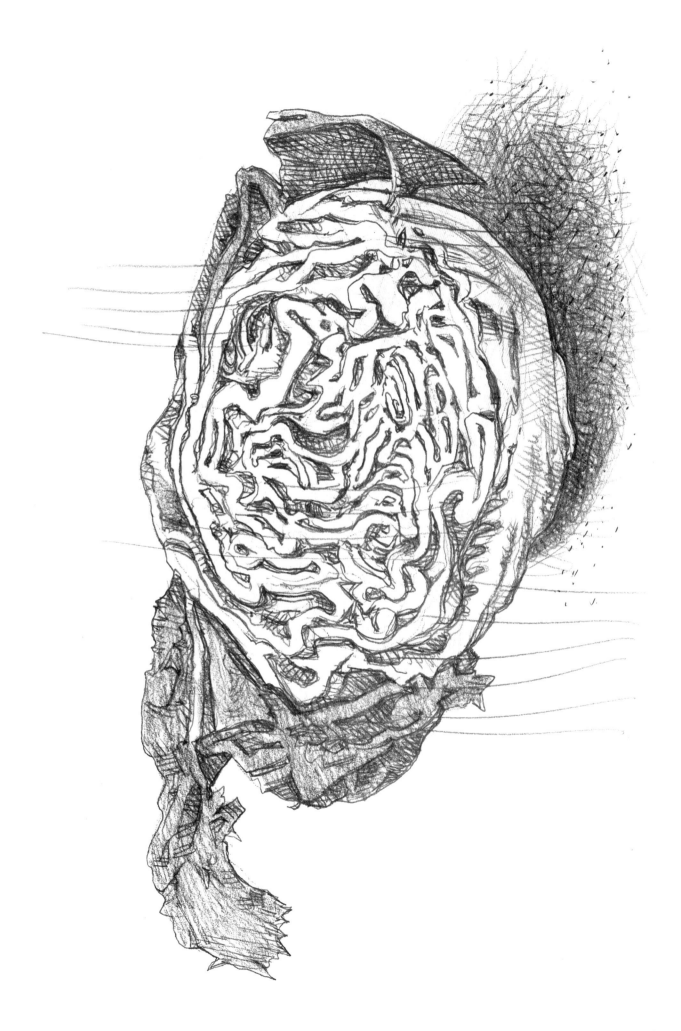

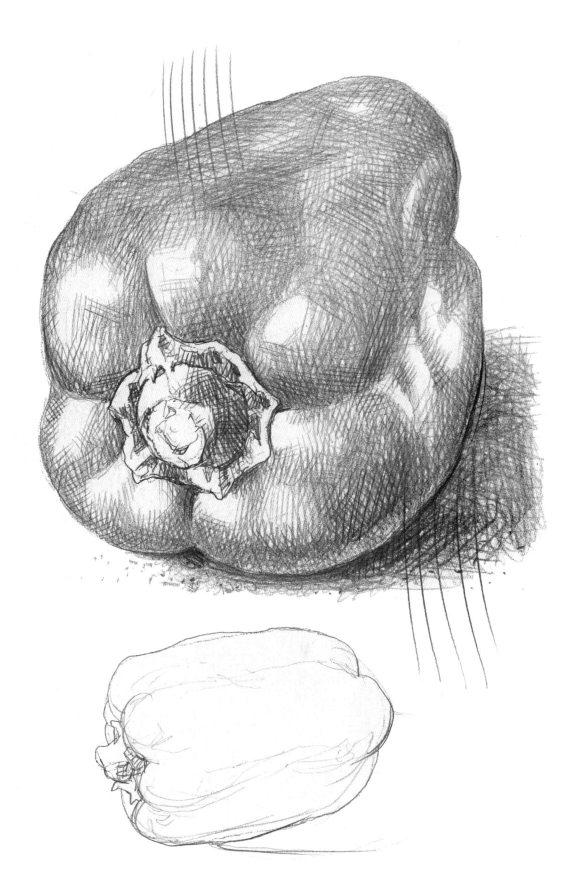

The smooth, glossy skin of a yellow sweet pepper is a source of bright, highly localised reflections. This vegetable also has rather thin partitioning walls that are easy to study in longitudinal section. Under strong lighting, this characteristic leads to some areas of the fruit becoming translucent.

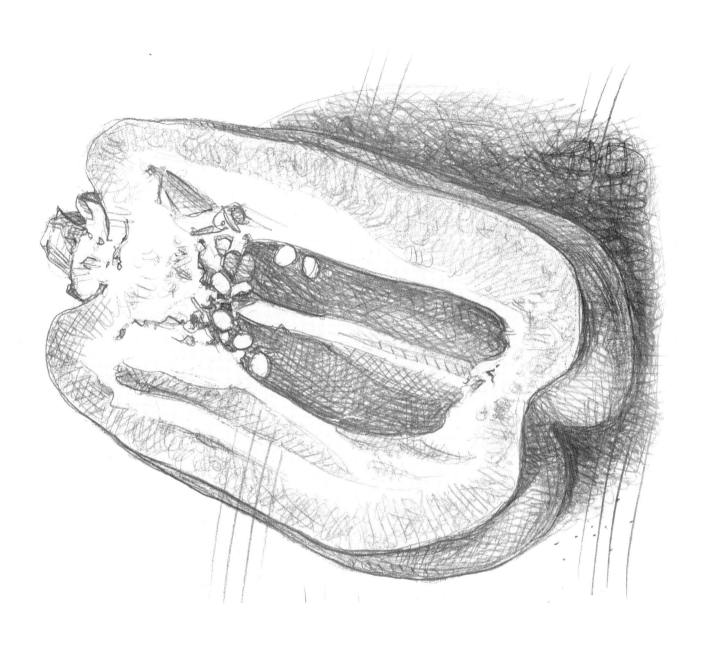

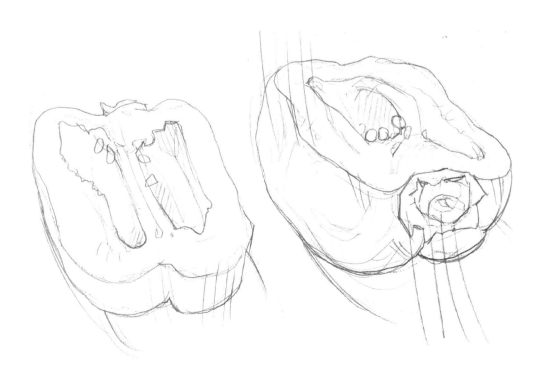

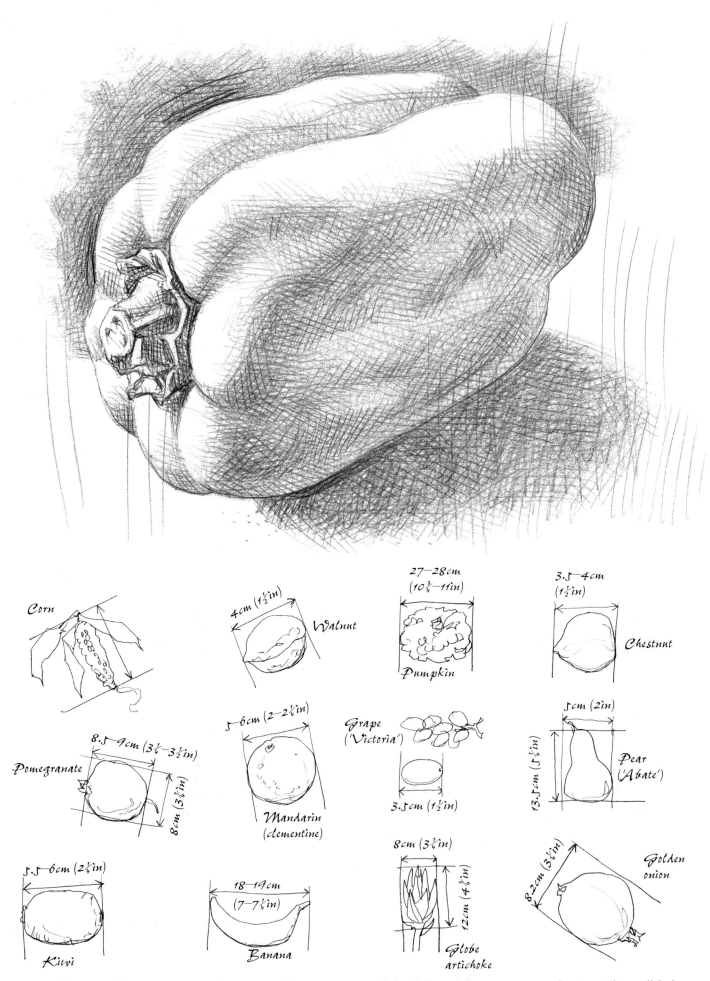

Corn

Walnut — 4cm (1½in)

Pumpkin — 27–28cm (10¾–11in)

Chestnut — 3.5–4cm (1½in)

Pomegranate — 8.5–9cm (3¼–3½in) × 8cm (3¼in)

Mandarin (clementine) — 5–6cm (2–2¼in)

Grape ('Victoria') — 3.5cm (1½in)

Pear ('Abate') — 5cm (2in) × 13.5cm (5¼in)

Kiwi — 5.5–6cm (2¼in)

Banana — 18–19cm (7–7½in)

Globe artichoke — 8cm (3¼in) × 12cm (4¾in)

Golden onion — 8.2cm (3¼in)

It is useful to note down some approximate overall measurements of the fruit and flowers you are drawing. This will help you become accustomed to assessing proportions of various diverse features when you come to draw a mixed composition.